Dedication

To the late Dona Z. Meilach, an author who touched many lives through her books. What author could ask for more than that?

Mike Sohikian. *Expanding Your Mind by Reading*. Steel, cast concrete, patinaed with acid and metal particles. 12" x 6" x ∞. Installed at Genoa Library. *Photo, Mike Sohikian & Gail Sponseller*

Acknowledgments

I first thank the artist blacksmiths from around the world who submitted their work and shared information. Your interest in and enthusiasm for the project was inspirational. The Artist Blacksmith's Association of North America, ABANA, and ABANA's chapters across the United States and Canada have been very supportive. Through their magazines and newsletters, including *The Anvil's Ring*, the call for artists was successful. Everyone who participated had a high regard for the advances in metalworking that has taken place in the last ten years and their contributions have strengthened this work. You are sincerely appreciated.

Preface

This book introduces a growing readership to the widely varied and beautiful artwork created by today's talented and dedicated artist blacksmiths. Some of the artists featured here had works of theirs in Dona Meilach's earlier books, while others are new to this volume. This approach allows readers to witness the evolution of artwork created by individual artists. It is hoped that this will be a continuing source of inspiration for artist blacksmiths, architects, designers, potential clients, and all who enjoy the solid beauty of artful metalwork. In this volume, the artists have described their artwork themselves, sharing their intimate knowledge of the pieces in their own words. The beautiful examples of their artwork are found both as part of the public landscape and within the confines of private homes.

Ironwork Today 2
Inside & Out

Jeffrey B. Snyder

Schiffer Publishing Ltd®
4880 Lower Valley Road Atglen, Pennsylvania 19310

Other Schiffer Books on Related Subjects:
Decorative & Sculptural Ironwork. Dona Z. Meilach
Art Deco Ironwork & Sculpture. S.F. Cook & T. Skinner
Direct Metal Sculpture. Dona Z. Meilach
The Contemporary Blacksmith. Dona Z. Meilach
Architectural Ironwork. Dona Z. Meilach
Ironwork Today. Dona Z. Meilach
Fireplace Accessories. Dona Z. Meilach
Art Nouveau Ironnwork of Austra & Hungary. F. Santi & J. Gacher
Decorative Architectural Ironwork. Diana Stuart

Copyright © 2008 by Schiffer Publishing
Library of Congress Control Number: 2005028431

All rights reserved. No part of this work may be reproduced or used in any form or by any means—graphic, electronic, or mechanical, including photocopying or information storage and retrieval systems—without written permission from the publisher.

The scanning, uploading and distribution of this book or any part thereof via the Internet or via any other means without the permission of the publisher is illegal and punishable by law. Please purchase only authorized editions and do not participate in or encourage the electronic piracy of copyrighted materials.

"Schiffer," "Schiffer Publishing Ltd. & Design," and the "Design of pen and ink well" are registered trademarks of Schiffer Publishing Ltd.

Covers and book designed by: Bruce Waters
Type set in Arrus Bd/Zurich BT

ISBN: 978-0-7643-3064-3
Printed in China

Schiffer Books are available at special discounts for bulk purchases for sales promotions or premiums. Special editions, including personalized covers, corporate imprints, and excerpts can be created in large quantities for special needs. For more information contact the publisher:

Published by Schiffer Publishing Ltd.
4880 Lower Valley Road
Atglen, PA 19310
Phone: (610) 593-1777; Fax: (610) 593-2002
E-mail: Info@schifferbooks.com

For the largest selection of fine reference books on this and related subjects, please visit our web site at **www.schifferbooks.com**
We are always looking for people to write books on new and related subjects. If you have an idea for a book please contact us at the above address.

This book may be purchased from the publisher.
Include $5.00 for shipping.
Please try your bookstore first.
You may write for a free catalog.

In Europe, Schiffer books are distributed by
Bushwood Books
6 Marksbury Ave.
Kew Gardens
Surrey TW9 4JF England
Phone: 44 (0) 20 8392-8585; Fax: 44 (0) 20 8392-9876
E-mail: info@bushwoodbooks.co.uk
Website: www.bushwoodbooks.co.uk
Free postage in the U.K., Europe; air mail at cost.

Contents

Preface .. 4

Chapter 1. Ironwork ... 6

Chapter 2. All-encompassing Projects 10

Chapter 3. Railings & Grilles 26

Chapter 4. Fences, Gates, & Doors 43

Chapter 5. Sculpture ... 66

Chapter 6. Furniture ... 133

Chapter 7. Outfitting a Fireplace 175

Chapter 8. Lighting Fixtures & Candle Holders 197

Chapter 9. Decorate Doors Dynamically 216

Chapter 10. Still There Is More 221

Bibliography .. 254

Resources .. 254

Index .. 256

Chapter 1
Ironwork

Blacksmiths have produced wrought iron tools and weapons since the twelfth century B.C. As the art of the blacksmith spread throughout Asia and continental Europe, in time ornamental ironwork was added to the utilitarian works created. Early surviving examples of the blacksmith's art include C- or S-shaped door hinges dating from the twelfth century A.D. Vine scrollwork was added to hinges and grilles a century later. As the years passed, wrought-iron architectural decorations expanded in scope and intricacy, including Gothic tracery, classical motifs, plant forms, delicate neoclassical ornamentation, and rococo broken curves. By the mid-seventeenth century, stair railings, iron balconies, large and impressive gateways and fences adorned with scrollwork and foliation were all the rage in France. Jean Tijou brought this French passion for ornamental ironwork to England around 1700. Meanwhile, across the sea in America, a simple, restrained style was preferred in the 1700s. Testimony to the skills of blacksmiths from this period may be found on many archaeology sites in the United States and overseas, where nails, horseshoes, hinge fragments, gun parts, and other useful objects have been recovered from the earth.

During the early nineteenth century, demand for timber framed housing rose dramatically, and with it the demand for nails. At the dawn of the nineteenth century, nails were produced one at a time by blacksmiths and they were expensive, as the process was slow. By mid-century, nail factories had opened, producing nails far faster and cheaper than any blacksmith could. Blacksmiths lost a product line and more would go as the century progressed. While, at the turn of the twentieth century, blacksmiths were still a vital part of the local economy, the advent of the automobile, mechanized farming equipment, and the factory assembly line would further reduce the need for items from the blacksmith's forge. One of the last bastions of the blacksmith, architectural ironwork, was lost with the Great Depression of the 1930s. Now mass production replaced wrought iron with cast iron produced in factories and by mid-century things looked bleak for blacksmiths.

Interest in the art of blacksmithing returned in the 1970s, with an increase in arts and crafts generally. Today, there are as many as 30,000 practitioners of metal arts in the United States. Roughly 10,000 of these are blacksmiths, 5,000 of which are members of ABANA, the Artist Blacksmith's Association of North America. (Columbia Encyclopedia 2007; Allen 2008) Others practice the associated arts of armourer, bladesmith, farrier, and gunsmith. Today's artists produce truly impressive works, creating works of metal sculpture, architectural ironwork, and a wide variety of additional items, as you will see.

Photo, John Rais Studios

Blacksmithing Tools

Familiarity with certain terms and tools of blacksmithing will increase one's understanding of and appreciation for the artwork displayed. Iron ore is heated in forges, creating "blooms" of hot iron. These blooms are pulled from the forge with large tongs and placed on an anvil. There the raw iron is hammered into a flat, rectangular bar. The bar is folded over and hammered several times, removing impurities from the iron in the process. The finished bar is an ingot of wrought iron. The term wrought iron refers to low carbon iron that is much softer than steel and far easier to shape when heated. In 1919, wrought iron was defined by John Jernberg as, "a fibrous structure with stringy streaks of slag running lengthwise through the bar, giving it a decided fiber similar to wood." (Jernberg 1919, 1) The laminations, or layers, in the wrought iron give it far greater strength than it would have in one layer alone, enough strength to allow wrought iron to be used for gun barrels. Wrought iron has long been produced in blacksmith shops. Foundries create cast iron. Cast iron is hot, liquid iron that is poured into molds lined with sand and clay. Given the sandy mold lining, the surface of finished cast iron has the rough texture of the sand. Today, some decorative ironwork, grilles for windows and doors, and iron fences are cast. While wrought iron can be welded, reheated, and shaped again, cast iron is brittle and cannot. (Allen 2008)

Mild steel is a term encountered frequently. Mild steel is low-carbon steel and is also referenced as soft-cast steel. Mild steel is an iron alloy that is widely used today.

John Jernberg described the classic forge as, "While forges or fires are of many shapes and sizes, the principles of their construction remain the same. An ordinary blacksmith forge is a fireplace in the bottom of which there is a tuyere for admitting a blast of air to blow the fire. Where the air blast is furnished by a hand bellows, the pipe leading therefrom to the tuyere is open throughout. When a power-driven blower furnishes the blast, there is a valve in the pipe for regulating it." (1919, 2) In the modern sense the forge may refer to either the blacksmith's shop as a whole or to the forge table, or hearth, itself.

Bill Robertson's Applecross Forge. *Photo, Bill Robertson*

Bill's forge and working area. *Photo, Bill Robertson*

Anvils come in many shapes and styles. Early anvils were roughly fifty-pound square blocks. Today's anvils may have one or two horns, or none at all. Whatever the form, an anvil must be heavy enough to absorb the blows struck upon it with hammers and sledges without moving. Frequently, an anvil's face has two holes in it close to the heel, one square and one round. The round hole is called the Pritchell and the square hole the Hardie. The Hardie holds a variety of tools, giving the blacksmith a helping hand. The Pritchell hole is used when punching holes through hot iron without damaging the anvil's face.

Among the most common tools are a variety of hand-held hammers. Hammers range in weight from one to sixteen pound. The heavier hammers are referred to as sledges and require a two handed grip for proper control.

Photo, Steve Hackbarth

George Witzke is in the final stage of making a morning glory flower in 2007. *Photo, April Witzke*

Michael P. Dillon is forging 6" solid iron on his 750lb. Niles, Bement, Pond steam hammer. There are hammers, and then there are *hammers.* Michael states, "This is an industrial forging hammer that we rebuilt and installed in my studio for creating sculpture. The moving die of this machine weighs 750lbs and can deliver a blow 120 times a minute with the force of 6800 foot pound of energy. It may be the largest forge hammer owned and operated by an individual in the United States."

Tongs and vices are also used to hold hot iron being moved from one place to another or during work, along with chisels, fullers, and any number of other useful tools. (Appalachian Blacksmiths Association, 2008)

Albert Paley and his staff work on the *National Cathedral Gate* in his Rochester, New York, studio, *Photos, Bruce Miller*

Chapter 2
All-encompassing Projects

Here are projects where artist blacksmiths and their assistants have been challenged to create a cohesive theme throughout the commissioned site, whether it is a home, an office, or a structure or site open to the general public.

Intracoastal Iron

The artist blacksmiths at Intracoastal Iron stated that their iron work at the private residence in New Bern, North Carolina, was complementary to the French country genre of the home. The exterior handrails and window guards have free flowing, organic elements, which reflect the beauty of the landscaping. This organic feel is structured with the symmetry of scrollwork, which sets the mood for the interior railing. The interior railing's more traditional structure brings you into the home and prepares you for the more formal aspects of your surroundings.

Intracoastal Iron. Exterior railing: These railing for the private residence in New Bern, North Carolina, are mainly composed of 1/4" x 1" mild steel flat bar. They have brass flower inlays to set the tone for the brass handrail inside the house. Each rail is approximately 6' long. Window guards: The window guards are composed of mainly of 3/4" x 1/4" mild steel flat bar. They have two different styles of forged flower accents throughout the design. Each panel is 23" wide and 6' tall. *Photo, Eric Hernandez*

Intracoastal Iron. Hand forged handrail: This handrail is located in the private residence in New Bern North Carolina. It is composed of 3/4" mild steel bar stock and finished off with a solid brass cap rail. This railing is approximately 50' long. The fluid grace of the railing matches and enhances the gentle spiral of the staircase itself. *Photo, Eric Hernandez*

Greg Eng

Greg Eng designed and produced the exterior railing, main entry stair railing, and back railing for the Fairbanks Ranch, a private residence.

Greg Eng. Exterior Railing: The railing is finished in powder coated flat black. The 50' exterior rail was designed by Greg Eng to fit between the residence's front and side arches. The 3/8" x 1 1/2" textured top cap was fastened to 1/2" x 1" with 1/4"-20 FHSC machine screws. The pickets are 5/8" square bar and 3/8" x 3/4" scrolls floating bars were made from forged molding wrapped around 11/16" x 3/4" spacers and two 5/8" square bars. The bottom rail is 3/8" x 1" with 1" x 1" x 3 1/2" long foot with 4" x 4" forged foot plates attaching to the deck. *Photos, Brenda Eng*

Greg Eng. Back Stair Railing: This 7' steel railing with a bronze newel post reflects the same design as the main stair. It has a sandblast and acid wash oiled, rubbed bronzed finish. *Photos, Brenda Eng.*

Greg Eng. Main Entry Stairs: Interior stair railing of steel with a bronze newel post consists of 7 lin. ft. of straight, 3 lin. ft. of curve, 19 lin. ft. of helix (slope and curve), and termination detail with a bronze newel post and finial. The 3/8" x 1 1/2" textured top cap is fastened to 1/2" x 1" with 1/4"-20 FHSC machine screws. The pickets are 5/8" square bar and 3/8" x 3/4" scrolls floating bars made from forged molding wrapped around 11/16" x 3/4" spacers and two 5/8" square bars. The bottom rail is 3/8" x 1" fastened to the bottom plate of 3/8" x 1 1/2" with 5/16"-18 FHSC machine screws. The finish is sandblast and acid wash, oiled, rubbed bronzed.
Photos, Brenda Eng

Mountain Forge

According of the artist blacksmiths of Mountain Forge, "Corbo is a house located in the gated community of Lahontan, California. The entryway is the most spectacular portion of the house. Copper plates and forged lags make up the entire metal used for the entryway. Faulkner Architects did the house design; our style of metal work matches the style of houses that Faulkner designs. The fireplace doors at the house were the first doors that David Tormey ever built. Dave also cut all the copper pieces for the entryway of the house."

Mountain Forge. Corbo entryway.

Mountain Forge. Interior sliding doors.

Mountain Forge. Fireplace screen and andirons.

Matt Canaday

Matthew Winn Canaday has developed his artistic talents through ornamental ironwork and multi-metal sculpture. He apprenticed for four years (2000 – 2004) under master blacksmith artisans Bob Bentley and Russel Windbiel in Paso Robles, California. His reputation for fine craftsmanship and design has brought him many opportunities to create a wide variety of products, from gates and railing, to lighting, sculpture, signs, and hardware. He strives to provide the utmost quality and design to his customers, no matter what the product may be. Matt finds satisfaction in providing his experience, and expertise, to create beauty and function through the medias of metal.

Moresco Plaza: Commercial office spaces and corporate headquarters of Midland Pacific Homes. The basis of the design was, as stated by Steve Kallar (interior designer, and master artist), to be: "A modern feel with traditional lines." From this standpoint, Matthew Canaday created the design of the railings for the plaza. A total of 250 linear feet of guardrail was commissioned, including two stair railings and one 20-foot section of interior railing. Designed and fabricated by Canaday Designs.

Matt Canaday. *Photos courtesy of Cameron Ingalls, Inc.*

Matt Canaday. *Photos courtesy of Cameron Ingalls, Inc.*

Matt Canaday. *Photos courtesy of Cameron Ingalls, Inc.*

Matt Canaday. *Photos courtesy of Cameron Ingalls, Inc.*

Andrew Leritz

Andrew Leritz and his brother James started their Deform studio in 1990 to produce studio furniture and custom ironwork in San Diego, California. From 1990 to 2001, they completed many custom commissions for both residential and commercial clients as well as producing five furniture lines that they have manufactured and distributed around the nation. They also completed a major public art commission for the City of San Diego, the Little Italy Landmark Sign, finished in 2000. In 2001, James and Andrew went their separate ways. Andrew Leritz moved to Portland, Oregon, where he continued to produce work under the Deform name. In 2003, Brett Geller joined Deform as a partner. Brett first worked for Deform in San Diego for a number of years before starting his own shop.

r3 Building

Andrew Leritz describes the r3 Building project: "The r3 Building project was completed in 2007. It is located in San Diego, California, and was designed and built by Lloyd Russell AIA. Both Brett and I have worked with Lloyd on a number of buildings and continue to travel to San Diego to assist with projects. On the r3 project, we were asked to produce railings in public areas and to collaborate on the 'Drawbridge'.

Because of the complexity of the building's design, we chose to fabricate and finish the railings onsite. They are made of mild steel with a painted finish.

The Drawbridge is a 10' h x 18' w window opening in the building that can be lowered with two winches working in tandem to become an outdoor deck 16' above the ground. The window is made of a 4" square tube frame with 2" square tube mullions. It is glazed with 1" thick tempered glass. The whole assembly is hinged at the bottom of the frame and weighs 6500 lbs. Because of the size and weight, Deform fabricated the window onsite as a single unit. Aaron Brooks of San Diego also helped fabricate and weld on this project."

Andrew Leritz. East exterior elevation of the building showing the "Drawbridge," during fabrication, partially closed. *Photo, Andy Leritz*

Andrew Leritz. West exterior elevation of building with the public stairs visible in the lower left with railing partially completed. *Photo, Andy Leritz*

Andrew Leritz. North end of the r3 Building, showing the exterior stair rail under construction. Pictured is Brett Geller. *Photo, Andy Leritz*

21

Andrew Leritz. Public stair finished. View from the second floor entrance looking down. *Photos, Andy Leritz*

Andrew Leritz. Stair at north end of building finished. Photo is from landing looking up to building entrance. *Photo, Andy Leritz*

Andrew Leritz. Drawbridge window with fabrication complete, awaiting finish and glazing, partially open. *Photo, Andy Leritz*

Andrew Leritz. Interior view of second floor of the r3 building. The horizontal window at the right of the photo was built by Lloyd Russell and Ame Parsley.
Photos, Andy Leritz

Avalon Hotel

The Avalon Hotel project is located in Portland, Oregon, and was completed in 2002. Of this project, Andrew Leritz states, "I worked on the project solo. The work is located in The Avalon Hotel Spa and Fitness Club. I was originally approached to design and build the main fountain, but eventually created the other pieces as well. The concept for the fountain was to create some abstract figures to stand in the alcove. The three figures are 36", 44", and 48" h. They are made of forged 14g. copper sheets over stainless steel armatures. Water flows out of openings in the trays at the top of each figure and cascades down and into the pool formed by the depression in the floor. Ten of the small fountains were created for the treatment rooms. They are made up of a forged steel base and an 18" diameter spun copper bowl. The magazine racks are forged steel."

Andrew Leritz. Spa Entrance. Forged steel and cut glass. Located in the entrance atrium to the Avalon Hotel Spa and Fitness Club. 60" w x 72" h. *Photo, Andy Leritz*

Andrew Leritz. Avalon Sign. Hammered copper logo. Laser-cut copper letters. Mounted behind the spa's reception desk. 24" h. *Photo, Andy Leritz*

Andrew Leritz. Small Fountain. Forged steel, spun copper bowl. A total of ten of these fountains were built for the individual treatment rooms. 36" h. Bowl, 18" d. *Photo, Andy Leritz*

Andrew Leritz. Spa Reception Desk. Forged copper "Pebbles," various sizes. A trail of river rock pebbles set into the floor leads from the spa entrance around the lobby to the main fountain. As the trail winds past the reception desk, the "Pebbles" become copper and flow onto the face of the reception desk. *Photo, Andy Leritz*

Andrew Leritz. Fountain. Forged copper over stainless steel armatures. Water flows from the tray forged into the top of each figure and cascades down into the pool formed by a depression in the floor lined with river rock. *Photo, Andy Leritz*

Andrew Leritz. Magazine Rack. Forged steel. *Photo, Andy Leritz*

Chapter 3
Railings & Grilles

Wrought iron railings graced Westminster Abbey as early as the thirteenth century. The mid-seventeenth century French passion for wrought iron railings, fences, and gates is alive and well in the United States today. This is easily seen in New Orleans' French Quarter.

Artisan-blacksmiths produce a wide range of beautiful, one-of-a-kind railings, adding grace and elegant design to what would otherwise be simply functional objects. Well-conceived designs for railings add character to a structure and may be used to reflect the environment in which a home or office resides. It does not take long to note the great difference in appearance between these original creations and their mass-produced, prefabricated counterparts.

The wrought iron grille attained great heights in decorative development in Spain from the Romanesque period (1000-1137 A.D.) through the Renaissance (14th – 17th centuries). During this period artisans produced *rejería*, screens designed to securely enclose but not mask from sight sacred treasures of the Church placed upon the high altars. The individual *rajas* during the Romanesque period had featured many scrolls topped with crests. By the sixteenth century, bars were replaced with rows of decorative balusters with ornamental cresting. Stunning examples of this work were found in the cathedral at Seville and the Royal Chapel in the Granada cathedral. Today, artisan-blacksmiths continue to make grilles, although their purposes tend to be less elevated than the protection of religious icons and relics. Today's grilles for windows and doors provide both a sense of historicity and practical security.

Manuka Forge Inc. creates some sophisticated, distinctive railings. Manuka Forge Inc. consists of John Monteath and Brenda Field. He is a New Zealand born blacksmith and she is a Canadian artist. For the past twelve years they have been producing beautiful architectural ironwork, furnishings, and sculpture for private clients from their studio in the Rocky Mountain foothills outside Calgary, Canada.

Manuka Forge. Railing. Forged and fabricated railing with repousse leaves, cast bronze rosettes and maple hand cap. Paint and guilders paste finish. 110′ long. {above and opposite}

Manuka Forge. Detail of forged and fabricated railing with repousse leaves, cast bronze rosettes, and maple hand cap. Paint and guilders paste finish.

Manuka Forge. Railing Forged and fabricated mild steel stair railing with a black wax finish. 105′ long.

Teresa Jenkins runs her operation, Happy Trail, from Toronto, Canada. She worked in the film industry as a Prop Master for twenty years. While she created props and puppets in a very creative environment, what she created was almost always following someone else's vision. In the summer of 2000, Teresa Jenkins states, "on a quest to find something of my own, I took an 'educational' holiday and spent a week hammering metal into garden art … and fell in love with blacksmithing!" She tells this tale about her first job as a blacksmith, after graduating from the Haliburton School of the Arts as an Artist Blacksmith. That first job would lead to the collaboration that would create the railing shown here. Teresa states, "The Birch & Thistle Window Grills were originally commissioned to Lloyd Johnston (one of my teachers) who asked me to do the design for the job and he would do the actual smithing – so I designed it and with his thirty plus years of experience in mind, never dreaming that due to unavoidable time conflicts that I would be the one who would be forging the grills! So, never underestimate what you can do – anything's possible with help from your friends! Lloyd and I also collaborated on the Fruit Railing as well, once again I did the design work and we both forged the railing. The lesson on this job was always go back to the job site to double check your measurements – especially if the site is still under construction … they changed the flooring between our first site visit and installation and didn't happen to mention it to us – so from the very first tread, all the way down three flights of stairs, we were out of step (but so were they as none of the steps had the same rise and run). In the end, everybody was very happy, but that's one trail I don't want to go down again!"

Teresa Jenkins. Fruit Railing. 2005. Designed by Teresa Jenkins, Happy Trail Prods. Inc., forged by Teresa Jenkins & Lloyd Johnston. This interior Fruit Railing made of mild steel and features a wax finish. Installed in a private residence in Toronto, Ontario, Canada. The client, a homebuilder, wanted a railing for his own home that was being built. He mentioned grapes & vines & the design literally grew from there to include the grapes as well as pears, apples, cherries, pomegranates, nectarines, & passion fruit. We forged about 35' of railing and a handrail as well. *Photo, Teresa Jenkins*

29

John Boyd Smith. Banana Leaf Railings – Miami, Florida. The Banana Leaf railings were created for the Loews Miami Beach Hotel in South Beach, Miami. The railings are forged mild steel with a faux-bronze patina. The large project required 700 lineal feet of hand railing. Approximately 5,000 banana leaves were forged to complete the project. Loews South Beach is a 1,000-room luxury resort hotel.

John Boyd Smith

John Boyd Smith's railing takes its inspiration from nature. Mr. Smith has been Savannah, Georgia's internationally acclaimed blacksmith, iron sculptor, and metalsmith for almost a quarter of a century. His work has appeared in several of Dona Meilach's previous books. In 1999, Mr. Smith was awarded a lifetime achievement award from the American Institute of Architects, State of Georgia. He is currently showing his sculptural work at the National Craft Gallery of Ireland in Kilkenny, Ireland. His metalwork adorns luxury private residences and luxury resort hotels throughout the eastern United States and Caribbean Islands.

Lisa Elias produced a graceful railing in harmony with the interior of the Armenian Church in St. Paul, Minnesota. The grille was commissioned by a local clinic. Lisa Elias works from her studio in northeast Minneapolis, Minnesota. Of her work, she states, "I am inspired by traditional blacksmithing techniques. I have been creating elegant, functional sculptures for the last seventeen years. I draw on simple organic forms to fabricate my work. A linear, fluid touch allows me to create a diversity of sculpture from fences, gates, and benches to light fixtures and arbors. The true power of my artistic ability is to harmonize the disparate elements of steel and gracefully turn it into organic, sophisticated sculpture."

Lisa Elias creates metal work for individual homeowners, architects, and designers. She has been self-employed since 1991. She was one of the artists selected to create a Public Art Fence for the City of Minneapolis in 2006. Her work has also been exhibited in museums and galleries across the United States.

Lisa Elias. Grille. 2007. This is one of three grilles commissioned for a clinic in Minneapolis, Minnesota. Mild steel. 46" w. x 24" h. *Photo, Andrea Rugg*

Lisa Elias. Railing for Armenian Church in St. Paul, Minnesota. 2003. Mild steel painted and powder coated. The railings were approximately 200' long. *Photo, Andrea Rugg*

Kevin Peffers provides examples of interior and exterior railing designs. Kevin Peffers currently owns and operates his own business in Burlington, Ontario, as an artisan blacksmith, cabinetmaker, and designer. For close to six years Kevin has designed, built, and installed all manner of iron and woodwork. Notable projects have included interior and exterior railings, front entryways, and bedroom furniture. Kevin is currently the editor of *The Iron Trillium*, the journal for the Ontario Artist Blacksmith Association.

Kevin Peffer states, "My mission is to produce outstanding functional pieces of art. Be it a railing, a set of doors, some furniture, or anything else, the outcome must exceed the expectations of the client. Only by building a rapport with the client can I realize their needs and requirements. As an artist I must also satisfy my own artistic integrity. It won't leave my shop unless I am satisfied. I achieve this quality by completing every process of a project from the design right down to the finish and the installation."

Kevin Peffers. Arc Railing. Mild steel. 10 linear feet. This railing was commissioned by the homeowner to replicate a railing he remembered from his childhood home. The handrail is hand forged 3/8 x 2" flat bar. It follows a smooth, helical transition from practical handrail to elegant floor support and post. *Owner: T. Delitala, Oakville, Ontario. Photo, T. Delitala*

Kevin Peffers. Exterior Handrail. Mild steel. 16 linear feet. The homeowner wanted a railing with warmth and that was welcoming for their new home renovation. In this case mirrored handrails with their matched arcs lead the visitor to the front door. The Chicago bronze powder coat, over hot-dipped galvanized coating complements the exterior of the house and its surroundings. The installation of these railing was made easier with the use of a small, self-built truck crane to hold the off-balanced railings in place while the lead shields and fasteners were installed. *Owner: I. Dowding, Mississauga, Ontario.*

Kevin Peffers. Hall Railing. Mild steel & Jatoba. 6 linear feet. This home had an extensive interior renovation including the replacement of 50 linear feet of railing. This small piece of the entire commission was designed to serve as a dramatic and welcoming statement in the front hall or foyer. The ironwork is made from 1/2" square bar and is joined with collars. The "basket" shape was an interesting challenge that turned out better than expected. The wood handrail was hand carved to fit the sweeping curves of the ironwork. *Owner: M. Parker, Oakville, Ontario.*

Maria Cristalli added elements to an existing railing. Maria began blacksmithing in 1993. She built up a clientele designing and forging traditional and contemporary architectural ironwork, ironwork for the garden, home furnishings, and sculpture. She owns and operates her studio in Seattle, Washington. Her work has been exhibited at a number of gallery shows.

Maria Cristalli. Railing. 2006. Forged elements placed into an existing rail.

Shawn Lovell added distinction with her wine cellar railing. After graduating with high distinction from CCAC with a degree in sculpture and working as an artist's assistant, Shawn Lovell started Shawn Lovell Metalworks in 1996, setting up shop in Oakland, California. Shawn specializes in making one-of-kind and commissioned work, both commercial and residential, using both traditional and modern forging techniques. Her work has ranged from large-scale railings, gates, and arbors to fire screens and surrounds, lighting, furniture, hardware and much more.

Shawn Lovell at work on the tree bed in her Oakland Studio. *Photo, Shawn Lovell*

Shawn Lovell. Wine Room Rail. Steel railing for a wine cellar, 4' long.

James DeMartis states of his work, "I began working with metal in college and I've been sculpting and working with metal for over twenty years, seven of which while owning and operating my own business – James DeMartis Custom Metal Studio in East Hampton, New York. My work as a sculptor has been shown in numerous galleries in the New York metropolitan area, and as a craftsman my commissions adorn many beautiful homes and properties on Long Island and beyond. My focus as an artist blacksmith is always on artistry and fine craftsmanship and attention to detail is at the heart of all my work. I'm inspired by the tools of the trade (fire, hammer, and anvil). My sculpture and architectural designs are both treated like fine works of art. I enjoy demonstrating and teaching blacksmithing to my surrounding community."

James DeMartis. Wine Cellar Railing. The railing is 42" high and is hand wrought and welded to the pre-existing four structural columns. The stanchions are 2" thick solid, split and drifted to receive the 1" round horizontal rails. The railing is painted black to resist the somewhat damp cellar conditions. Also note the handrail, which wraps around and down the stairs into the heart of the cistern. The wine cellar itself was fabricated within an old brick cistern, which collected water for drinking within this house in historic Sag Harbor, New York. The cistern was capped off 6' down and has a diameter of 6'. It holds approx. 500 bottles. There are 16 "rings" which suspend each tier of wine. Each tier is anchored within the brick walls of the cistern and supported at intervals by forged stanchions, which repeat the finial style of the railing.

Todd Campbell created a railing with an aquatic motif. Todd Campbell has the following to say about his work, "In my work I deal with the connection between organic natural world and industrial materials, thinking about how objects are manufactured and exist in this postmodern age. In creating sculptural installations I begin by amassing pieces of metal that I have forged into a shape.

I investigate the idea of mass production in metalwork by taking one standard stock size of metal and transforming it in one or more steps of cutting or forging in a direct, repetitive action. By using fire and force, I allow the metal to return to the organic quality of the ore. I am careful not to overwork a single part, but utilize the malleability of the material.

I question the ideas of craft, production and conceptual artwork by creating simple forms that require an excess of hand labor and a critical eye to arrange. I love the idea of work and the process of converting energy into a shape.

One singular shape used repeatedly evolves into a system, similar to organic or biological patterns. The arrangements allude to natural forms like fungus, hair or plants. The patterns and configurations shift between the micro and macro scale."

Todd Campbell. Railing. 2004. Forged steel in an underwater botanical style. Commissioned by Armadillo Clay for their showroom in Austin, Texas. Approximately 14' l.

Lynda Metcalfe completed the exterior ironwork for the Portera residence, Chattanooga, Tennessee, in March of 2007. She states, "My design features decorative elements interspersed with tenoned and wrapped pickets; all the decorative elements are different except those on the corners of the balcony and those paired on either side of the slate column and copper down pipe. The themes were obvious and decorative joinery and the joins between the railing panels being worked into the decorative elements. One of the tricky aspects of this project was the lack of places to anchor to directly in line with the railing because of the slate cladding. Decorative anchor points and special bracketing was designed into the piece. The project was constructed in steel and took just over 1000 hours to complete."

Lynda Metcalfe and Elmer Roush. Exterior Ironwork for Portera Residence, Chattanooga, Tennessee. 2007. There is a total of 52' – 37' deck railing, and 15' of balcony railing. The fullered scroll featured at the corner was all hand forged by my husband, Elmer Roush, and myself out of 1/2" x 4" flat bar as our power hammer was out of commission at the time. *Photos, Lynda Metcalfe*

Jørgen Harle of Orcas Island Forge designed these forged handrails for the "Stage on the Green" project in 2006. The Orcas Island, Washington, community pulled together to produce this band shell structure made from locally harvested and crafted materials. Jørgen is also a mill-wright at a local sawmill, which milled the heavy structural timbers. The largest measured 10" x 16" x 52' and was used for the ridge beam. The structural steel brackets were a collaborative design between Jørgen and the team architect and engineer.

Jørgen Harle. Bull Kelp Rail. 2006. Forged steel handrails with rust patina. Heavily forged 1 1/2", 2", and 3" mild steel assembled with wraps, rivets, and TIG welds. 36" h, various lengths, 8' – 12'. Designed and forged by Jørgen Harle, Orcas Island Forge with the assistance of Jeff Holtby and Jake James. *Photos, Patrick Jordan*

Larry Langdon and Andy Blakney of Monster Metal. Ironwork Staircase Railing. Forged iron, bronze rivets, and wax finish. This railing resides in the home of Brian & Carol Gregory, Seattle, Washington. *Photos, Miguel Edwards*

Rachel and Timothy Miller. Stainless Steel Railing. The railing and staircase are made entirely from stainless steel. The inside of the railing is textured under the power hammer. Private residence: Long Island, New York.

Greg Eng designed and produced this patriotic grille for a memorial park.

Greg Eng. *Patriotic Eagle on Flag Grille*. Forest Lawn Memorial Park, Cathedral City, California. Steel finished with acid wash, blackened steel with a clear sealer. This project was done for The Forest Lawn Memorial Park. It is at the "Hall of Honor" in memory to all who served in the armed forces. The size of the grille is 83" wide by 91-1/2" high. Chasing and raising were preformed on the flag to give it shape, contour, and a 3-dimensional effect. *Photo, Greg Eng*

41

M. Craig Campbell created this Fishtail Grille, which he states has many uses. Of his work, M. Craig Campbell states, "Blacksmithing offers me an opportunity to create objects that are pleasing to view, to touch, and sometimes even to listen to. Using heat and hammer, I am always astonished by the plastic qualities of metal and ho wit can be coaxed into new and intriguing shapes. From lifeless, cold steel bars come sweeping vines, elegant furnishings, whimsical garden sculptures, graceful gates, and functional hardware. Influenced by the Arts & Crafts movement of one hundred years ago and by the mid-century modern look of fifty years ago, my efforts often emphasize minimalist designs that let the material and joinery speak for themselves."

M. Craig Campbell, Blacksmith

M. Craig Campbell. *Fishtail Grille*. 2006. Steel, rust, tung oil. 38" h x 33" w x 4" d. Forged using traditional blacksmith techniques and joinery. The *Fishtail Grille* can be many things: window security shielding your family from danger, a decorative element mounted on your fence or garden shed, a trellis for vines to climb, or an interior feature element on your wall. It was forged from 11 feet of 1/2" x 1 1/2" flat steel bar using traditional blacksmith techniques. If laid end to end the seven individual elements now measure just over 22 feet. *Photo, Trent Watts*

Chapter 4
Fences, Gates, & Doors

Today's artist blacksmiths produce a wide range of fences, gates, and doors known for far more than their solid security. While some examples of this form of artistry will reflect the historical style of the buildings the surround or grace, others take on wildly imaginative forms and include decorative ornamentation including flora and fauna and amazing geometries, to name but a few.

Both wrought iron and cast iron fences of decades past included a variety of forms, including picket, hairpin, hairpin and picket, bow and picket, and scalloped. These fences often included wrought iron rails with cast elements attached for decoration. Such is not the case with the fences found here.

Albert Paley has been active as an artist for over thirty years. At his studio in Rochester, New York, he and his staff work in a variety of metalworking disciplines. Albert Paley is the first metal sculptor to receive the coveted Lifetime Achievement Award from the American Institute of Architects, the AIA's highest award to a non-architect. "The allure of Paley's art comes though its intrinsic sense of integration of art and architecture," as one noted architect stated.

Commissioned by both public institutions and private corporations, Paley has completed more than fifty site-specific works. Shown here are his Memphis Portal, National Cathedral Gate, and Animal Always Entryway.

Albert Paley. *Memphis Portal*. 2005. Forged and Fabricated Steel. 15' h x 17.25' w x 1' d. *Collection of the Memphis Brooks Museum of Art, Memphis, Tennessee. Photos, Bruce Miller*

Albert Paley. *National Cathedral Gate.* 2007. Forged, Formed and Fabricated Mild Steel, Brass, 24k Gold Plate. Naturally rusted patina. 9' tall x 5.3' wide x 1.6' deep. Located at the National Cathedral, Washington, DC. *Photos, Bruce Miller*

Albert Paley. *Animals Always.* 2006. Forged, Formed, and Fabricated Corten Steel with a naturally rusted patina. 36' tall x 130' long x 8' deep. Located at the entryway to the St. Louis Zoo, Forest Park, St. Louis, Missouri. *Photos, Bruce Miller*

46

Lisa Elias. *Stream of Trailing Reeds* Fence. 2006. Corten Steel. This was a commission from the city of Minneapolis. The fence is 400' long and 6' high. Cattails and leaves run throughout this fence. The fence runs along an entrance to a freeway ramp and a bike path in Minneapolis.

Lisa Elias. Garden Gate. 2007. Mild steel, powder coated and painted. 52" h x 34" w. The leaf on the side is the latch.

Maria Cristalli. Bronze Gate. 2003. Silicon bronze "branches" form this gate. 7' x 6'. The detail shot shows the hinges, texture, and ties that appear to hold the branches together.

Maria Cristalli. Bronze Fence. 2003. Silicon bronze has been forged and textured to look like branches that have been tied together to form a fence. 2.5' x 24'.

Maria Cristalli. Angle Iron Gate. 2006. Angle iron has been spread open and riveted with spacers in between to give a layered look. Rusted with wax and oil finish. 3' x 2.5'.

John Boyd Smith. Sculptural Gate – Kiawah Island, South Carolina. This sculptural gate is the entrance gate to the Ocean Room, an exclusive restaurant at The Sanctuary, a five-star luxury resort hotel, on Kiawah Island, South Carolina. The double gate is eight feet high, and eight feet wide and depicts wildlife of the Southern region. The double gate, when fully opened 180 degrees, is designed to serve as two sculptures against neutral walls as the background. This was a design feature that the owner insisted upon, so that the gate could be enjoyed in both closed and open positions.

John Boyd Smith. Tuscan Style Gate – Hilton Head Island, South Carolina. This Tuscan Style Gate is forged from mild steel, and is one of nine gates created for a luxury private villa in Hilton Head Island, S.C. The gate is four feet wide by eight feet tall, and features stylized floral medallions and florets.

Daniel Nauman has been forging iron since 1979. He founded Bighorn Forge Ironworks in 1984 in Kewaskum, Wisconsin. He has the pleasure of designing and forging chandeliers, wall sconces, fireplace tools, railings, gates, tables, sign brackets, door hardware, arbors, and much more for numerous homes and mansions. Daniel Nauman has this to say about the Port Washington Gate, "The 'Port Washington Gate' displayed here was made for a family that had two homes located on Lake Michigan—one in Chicago and the other in Port Washington, Wisconsin. The number '3' is repeated several times in the work (the three major elements in each pier; the vertical members of the gate leaves; and the dominant "flags" on top of the gate leaves) which represent the three members of the family. The two piers represent the two homes. In between them, the gate leaves indicate the turbulence, relationship, and harmony of the winds and waters of Lake Michigan.

Daniel Nauman. Port Washington Gate. 2007. Forged and painted mild steel. 108" h x 168" w x 12" d. *Photograph © 2007 George Lottermoser*

Michael Dillon owns and operates Dillon Forge, a blacksmith shop located in Roswell, Georgia, just north of Atlanta. Michael's methods stem from a strong background in sculpture, where metal is transformed using heat, hammer, and intuition. When Michael approaches functional work such as tables, railings, and gates, he focuses on a design that will reflect the clients' personal vision and elevate the object into a work of art. His primary medium is iron, however, he also works with stainless steel, brass, and bronze. Michael's work is produced specifically for each client, either commercial or residential. His stated goal is to forge a relationship with each client to bring forth a collaborative vision for highly crafted works of art.

George Parker. Entrance Gate to the courtyard of a private residence. Architect: Late/Flato. 48" w x 68" h. *Photo, George Parker.*

Michael Dillon. French Drive Gate. Forged iron. 16' h x 18' w x 3" d. Painted black. This double leaf gate weighs approximately 1000 lbs. The letter A at the center top is the owner's last name initial, and actually crosses to conceal the center part line of the gate.

George Parker. Cemetery Gate at a ranch in west Texas. Architect: Ted Flato. 48" w x 60" h. *Photo, George Parker*

George Parker. Ceremonial Entrance to the Children's Science Center at the Witte Museum. Architect: Lake/Flato. Approximate weight of this entrance is 2500 pounds. 16' w x 9' h. *Photo, Ansen Seale*

Darrell Markewitz first began his lifelong interest in both metalwork and history while a student at Ontario College of Art (Toronto, Canada) in the mid-1970s. Like many of the blacksmiths of the "back to nature" generation, he was primarily self taught. After College, he worked as an Artisan / Interpreter at a number of Ontario Living History museums. He re-located to Grey County (about 2 1/2 hours northwest of Toronto) in 1989 and established the Wareham Forge.

He has always been deeply influenced by ancient Celtic and Viking Age designs and artifacts. He calls his distinctive artistic style 'Rivendale', a blending of Art Nouveau with those historic lines. Much of his contemporary work concentrates on aggressive hand forging techniques and work with modern structural materials (pipe, angle and channel). He concentrates on intermediate sized one-of-a-kind pieces, primarily as private commissions, mostly objects for gardens (gates, fountains, arbors).

Darrell Marekwitz has this to say about his gate titled "Celts at the Gate - Spears and Shield," "The main point of inspiration to the design was the series of bronze shields discovered in England and Europe which date to the Celtic Iron Age (such as he 'Battersea Shield', from Middlesex, England, dated circa 200 - 100 BC). In this gate the basic frame is formed of a series of uprights made of channel (U-shaped) material suggestive of a line of spears. At the upper and lower ends the channel is cut apart to create three individual strips, then formed to the curves. The upper sections are further given a quarter turn to break up the long straight lines. The uprights are held together by a series of sweeping curves, the lines taken from embellishments on Celtic Iron Age parade shields. The thickness and width of the individual curved elements varies to create a depth to the piece.

In 2006, the original single panel was re-worked for mounting at Styll Gallery in Elora, Ontario. First a matching narrow companion panel was created, using the same kind of split end channel for the uprights, with similar sweeping curves and spirals as the body of the design. The paint was modified, with a spray coat of very dark blue applied over the bright blue base colour, with a touch of green highlights on some of the curves – a far more subtle use of colour."

Darrell Markewitz: the Wareham Forge: Experimental Iron Smelting. November 2005. The artist states, "Since 2001, I have conducted over 25 experimental iron smelts, attempting to re-discover what are now lost physical techniques that may have been used in Northern Europe in the post Roman period. Little remains in terms of archaeological evidence and that only the waste from a long and complex chemical process. The smelter seen here is constructed of a mixture of clay and straw called cobb to create a rough cylinder about 25 cm in diameter and at least 60 cm tall. As much as 100 kg of prepared charcoal is burned over the 6 - 8 hours of a smelt. If everything goes just right, the careful addition of 10 kg of prepared iron ore should yield a spongy iron bloom at about 3 - 4 kg."

In the first photo, Darrell is getting ready to run a steel rod down the tuyere to clear a blockage of congealed slag.

In the second photo, Darrell is adding iron ore to the top of the burning furnace part way through the smelt.

55

Darrell Markewitz. 2000/2006. *Celts at the Gate - Spears and Shield.* Forged mild steel with decorative paint.

57

W.R. Nager, a blacksmith in Lakeland, Florida, has been blacksmithing since the mid-twentieth century. While he started by shoeing racehorses, in his more than forty-five years of experience, W.R. Nager has become a full time designer in metals. He states, "After having my ankle broken, my ribs broken, and other parts injured, I finally gave up the shoeing of horses and devoted my life full time to metalwork. I went back to my studies. I took advanced blacksmithing courses; I studied architecture and design, but more than that, I studied my craft … I do hundreds of scale drawings for metal projects, including outdoor sculptures, which I love."

W.R. Nager. Forged Iron and Copper Entry Door with Screening. Private Residence, Oldsmar, Florida.

David Starr, of Chile Forge out of Tucson, Arizona, has this to say about the Abundant Harvest Gate, "The gate's origins stemmed from a client interested in encouraging new talent, a designer wishing to expand his boundaries, and a master smith willing to share his skills in a worthy pursuit. The 'Abundant Harvest' gate was a collaboration between myself as the designer and master blacksmith and teacher Tom McLane. I made a decision early in the process not to limit the gate design by my own novice blacksmithing skills. The experience of working along side the seasoned smith as we made our way through the challenges of translating the design offered many invaluable lessons."

David Star (gate design). *Abundant Harvest Gate.* Forged and fabricated by **Tom McLane and David Starr** with mild steel, copper, and brass, rust patina and Baroque Art Gilders Paste. *Photo, Michael Longstaff*

James Dunmire is a transplanted Philadelphia who is the blacksmith/owner of Waters Edge Forge in Chuluota, Florida (just outside Orlando). He discusses the beginnings of this blacksmithing career, "In 1995 I was approaching retirement age and wondering what I wanted to do with the rest of my life when I came across an article in the American Welding Society' *Welding Journal*, March 1995 issue about Artist Blacksmith Greg Leavitt in Glen Riddle, Pennsylvania. Upon retiring in 1998, I moved up to the New Jersey area, apprenticed myself to Greg, and drove down I-95 every day to learn and practice my new career. Returning to Orlando in 1999, I have attended many blacksmith meetings, conferences, demonstrations, and taken a variety of weeklong classes at John Campbell School in Brasstown, North Carolina, to observe and learn and develop my own methods, techniques, and artistic capabilities as well as a clientele."

James C. Dunmire. Garden Gate. 2001. Steel, hand forged. 5' h x 8' w. About this gate, James Dunmire states, "This was my first experience with a gate that I designed, built, and installed in the garden of our lake front home. It reflects the flora and fauna of our gardens. Day lilies were placed in one panel and cattails in the other, with vines and leaves growing up the posts. I also added one copper day lily for the interesting green weathering effect that contrasts with the rich brown oxidized rust color of the gate and posts. With so much of the learning curve to experience, this piece took me just about a year to complete."
Photo, Janet Scalise of Integrated Communications Solutions in Chuluota, FL

Zack Noble. Columbia South Carolina Gate. 2007. Forged steel. 46" x 70" x 1 1/2". *Photo, Mary Vogel*

Teresa Jenkins, Happy Trail Prods. Inc. Entry Gate. 2006. Mild steel, primed & painted. 5' 6" h x 3' w. Designed & forged by Teresa Jenkins. The entrance is located on street level to apartments located above a storefront in the east end of Toronto, Ontario, Canada. My client requested a decorative gate to dissuade loitering in the entrance to the apartments. *Photo, Teresa Jenkins (with owner's permission)*

Rodger and Jason LaBrash produced the wine room door shown here for a private client. In October 1987, Rodger LaBrash officially opened Grizzly Welding and Custom Fabrication. Early on, Grizzly performed many different small fabrication tasks from gates, fences, and railings, anything that involved steel and welding. Over the years works of greater sophistication have been undertaken. Today Grizzly Iron, Inc. is a family run business with Rodger and son Jason working to design, fabricate, and install our client's request for high quality ironwork.

Rodger & Jason LaBrash. Wine Room Door. Jason LaBrash tells how this door came about, "A good client of ours asked us to build a wine room door for an existing opening in her new house. The client wanted the door to have some organic elements but still have some traditional ironwork. We submitted the first design but it was rejected. Several months later we were told the door needed to be completed within eight weeks because a very important fundraiser was going to take place at the house. We started fabrication almost immediately without a final design. We received the final design a couple weeks later. Some of the design ideas had to be changed since the design was different from what was already built. The opening was finished before we built the door so the drywall and paint needed to be left untouched. We added a custom steel casing to the jamb of the door to finish off the opening so there would be no refinishing of the drywall The finish on the door was a Japanese brown which was made to run to achieve a wood grain effect. Then a clear coat was added to seal it."

In 1997, Mike Wolfe moved to an eight-acre farm and opened his door as an architectural blacksmith. He had been working as an assistant to a blacksmith for eleven years while operating Precision Photographics, Inc., a custom photographic laboratory. After twenty-two years, and 36 employees, he sold the lab, and he now works in his studio, Designs in Iron, doing hand-forged and hand-fabricated ironwork. He has been working on commissions since the day he started, forging railings, gates and other metal work including hand-forged flowers and the wine room door shown here.

David G. Robertson, an artist blacksmith in Cargill, Ontario, Canada, produced these elegant door grills with motifs based on nature. Speaking of his work, David Robertson states, "I am drawn to the beauty in nature of organic forms. Inspiration comes from animals, plants, flowing water and all things found in nature. The long, sinuous lines of the plant world easily translate in to the strong

Michael Wolfe. Wine Room Door with Grape and Grape Vine motif. This wine room will hold 4000 bottles and is temperature controlled.

David G. Robertson. Spring Garden Door Grille. Forged and fabricated mild steel, Honduras mahogany. 80" h, 34" w. Designed and Crafted for Soulwood Ltd. by David Robertson and Darrell Markewitz. *Photo, John Bielaski*

self-supporting nature of forged steel. Forging each element for a piece requires putting aside distractions and slowly coaxing the hot metal to shape. Occasionally the steel will take on an unexpected form that compliments the overall design. These discoveries form part of the unique nature of the work and are often what gives a piece a life of its own."

David G. Robertson. Calla Lily Door Grille. Forged and fabricated mild steel, Honduras mahogany. 80" h, 34" w. Designed and Crafted for Soulwood Ltd. by David Robertson and Darrell Markewitz. *Photo, John Bielaski*

Todd Campbell. Entrance Door. 2006. Designed and fabricated steel and etched glass. Commissioned by Lanny Vickery for a private home in Austin, Texas. 8' x 8'.

65

Chapter 5
Sculpture

The sculpture shown here is expressive and innovative, ranging from abstract to realistic and employing a variety of materials and techniques. The materials employed extend far beyond wrought iron.

Artist blacksmith Nicole Beck speaks about her three pieces displayed here. The Flux series wall reliefs explore the strength, flexibility, and tension of steel pierced and interwoven with an exotic hardwood and were created specifically for intimate interior spaces.

Asteray was newly created for the 2006 Lincoln Park Community Art Initiative (www.LPLVAI.org) outdoor sculpture exhibition. This exhibition is a privately-funded exhibition organized by Vi Daley, Alderman of the 44th ward of Chicago, Lincoln Park. Sculptures are juried by a professional panel and then placed throughout the ward for one year. Asteray was sited at North Avenue and Lake Shore Drive, near Astor Street and the Cardinal's Mansion on the southern-most edge of Lincoln Park. It was placed inside a cul-de-sac amongst foliage. This sculpture has very delicate linear elements and I recommend that in an outdoor environment it is best placed in an open grassy area, a waterfront, or in front of a brick/stone wall in order to accentuate the undulating lines of the tubular steel work.

Jet Stream was designed out of a body of work that had been exploring abstract metaphors for astronomical physics and dynamics. Many of these works had incorporated large lenses that would refract and distort the surrounding environment. I found through experimentation that the sun would cast lovely elliptical shadows on the ground during its trek across the sky if the lenses were left out of the holes that pierced the steel planes (much like a sundial.) These holes, some small and some very large really excited me in the way that light and landscape could be transmitted and encapsulated according to your vantage point and the particular position of the sun. These holes could "reframe" the surrounding landscape and was particularly evidenced when Jet Stream was located along the Chicago River in October 2003 for a one-month exhibition before traveling to Purdue. Jet Stream was sponsored by the Boeing Corporation in this exhibition organized by Chicago's Friends of the River. The 18-foot long channel beam that gracefully pierces Jet Stream's hole and also upholds and levers the sculpture at a dynamic angle simulates atmospheric jet streams. The channel was bent to exact specifications by a Chicago firm that also computer-engineered and rolled the wonderful stainless tubes that arc across Frank Gehry's Millenium park project. I have always been interested in reinterpreting the universe's and our own planet's natural forces and this piece is an expression in the progression of my inquiry.

Nicole Beck. *Flux I*. 2007. Steel and padauk wood. 3' x 5' x 3". *Photo, courtesy the artist.*

Nicole Beck. *Asteray* (maquette). 2006. Steel. 35" x 12" x 8". *Photo, courtesy the artist.*

Nicole Beck. *Jet Stream.* 2004. Painted steel. 8' x 7' x 18'. Site views: Chicago River at Lake Street and Wacker Drive, Chicago, Illinois and Purdue University, West Lafayette, Indiana. *Photos, courtesy the artist*

Jeff Benson, owner of Benson Designs LLC, started building in the Green Bay area in 1984. His passion for blacksmithing emerged in 1996. Given his background in construction, Jeff Benson is at home working with other trades on complex projects. He enjoys combining different media, like metal, stone, glass, and wood, constantly experimenting with new techniques to achieve powerful results. Here are two of his sculptures.

Jeff Benson. *Openings.* Forged mild steel with hand-formed molten glass. 26" l x 18" h. Elegant, intriguing lines open around a colorful glass center. *Photo, courtesy of Jane Benson*

Jeff Benson. *Morning Sun.* Forged mild steel and copper. 32" w x 30" h. Flowing steel with a hammered, heated copper disk creates a stylized, glorious sunrise on the water. *Photo courtesy of Ryan Commercial Photography*

68

Artist blacksmith Rudy L. Billing's interest in blacksmithing was sparked several years ago when he needed to place a 105 pound rock on a wall to complement a bronze sculpture. Since then, Rudy has been creating a variety of original items, including roses, crosses, and branding irons.

From his studio-workshop in Austin, Texas, Rudy utilizes his Bachelor of Science degree in Industrial Technology as the foundation for his work, allowing him to develop unique methods of forging iron.

Rudy L. Billings. Rose. The individual elements are forged together and dyed to create an everlasting rose. 1/4" round, and 14-gauge steel. The finished piece is a life-size 18" long stem rose.

Rudy L. Billings. Railroad Spike Cross. Made from a rusty railroad spike. The spike is slit and unfolded, creating a one of a kind cross. The finished piece is approximately 4" x 7".

A full-time studio sculptor since 1978, Bill Brown states, "The sculpture I create is an artistic transformation of life experiences, and my interpretation of the natural and spiritual world around me. My work involves the exploration of the plasticity of steel, and the challenges of transforming materials, thought, and energy into art." For Bill Brown, there is "…an initial struggle to get out of his own way in order to let God happen, while his ego-self hankers to 'do it right' on others' terms, grappling with personal fears and desires; this struggle is inevitable in order to create the kind of art that seems almost to have a life, a power, of its own. [Bill Brown states,] 'I find out where a piece was going only once it's done'." (Swensson 2007)

Bill Brown. *Guilty Bystander.* 2002. Forged steel & copper. 61" x 57" x 14". *Photos, Barnwell Photography*

Bill Brown. *Orion.* 2000. Forged steel with acrylic enamel. 77″ x 33″ x 16″.
Photos, fanjoylabrenz.com

Bill Brown. *Samurai.* 2006. Glass & Steel. 9" x 52" x 12".
Photos, Barnwell Photography

At the time of this writing, Anne Bujold was in her final year of metal work studies at Oregon College of Art and Craft, completing her BFA. The artwork displayed here, entitled Blooming, was inspired during a work-study scholarship experience in 2006 with artist blacksmith Alice James at the Penland School of Craft.

Anne Bujold. *Blooming.* 2006. Mild steel, forged and fabricated. 15" h x 28" l x 10" w. *Photos, Dan Kvitka*

M. Craig Campbell. Fiddleheads. 2007. Steel, paste wax, forged and fabricated. *Fiddleheads* came from a simple doodle I sketched. Each of the five fiddleheads was worked hot to first remove the mill finish and create texture, then the points were forged and the curves applied. 45" h x 24" w x 24" d. *Photo, Trent Watts*

M. Craig Campbell. Nouveau Spring. 2007. Steel, paste wax, forged and fabricated. Forged from 1" bar, Nouveau Spring evolved from the elements of a previous sculpture titled Fiddleheads. 56" h x 28" w x 6 1/2" d. *Photo, Trent Watts*

M. Craig Campbell. Bug. 2002. Mild steel, heat colored, clear paint finish, forged, traditional joinery. Bug's body was found at the scrap yard in almost the same profile you see now. Some minor changes were made at the body-head transition and then it was textured and domed. The legs came from 1/2" round stock and the antennae were 3/4" square to provide for the mass for their finials. Prominent traditional joinery was used and it was oven-colored to a blue-purple. The color changes slightly as you rotate it in the sun just like the iridescent colors of a real beetle. 17" h x 16" w x 16" d. *Photo, Hogarth Photography, Saskatoon*

M. Craig Campbell. Pulse 11 – 2005 Variety. 2005. Collaborator: Daryl Richardson (metal artist). Steel, rust and wax, forged and fabricated. A wonderful fun and freeing collaboration, the pod was intended to sit horizontally as a boat. Once we held it vertical we knew it was a seedpod and commenced forging the vine and peas. 34" h x 36" w x 36" d. *Photo, Hogarth Photography, Saskatoon*

Todd Campbell. *Spaceballs.* 2006. Painted forged steel sculpture, three sections shown. 72" x 32" x 32"; 42" x 30" x 30"; 29" x 20" x 20". These were created as a commission for Neiman Marcus for their Austin retail shop at The Domain. Three other sections were made as part of this piece and were purchased for private collections.

75

Jason Cole, an artist blacksmith member of Intracoastal Iron, has this to say about his vase, "My first piece [Battered Hive] was made at Penland, studying under Steven Yusko. Some of my inspiration also came from my professor at Kansas State, Elliott Pujol. We were suppose to make some kind of vessel and I had just gotten done reading a story about honey bee's."

Richard Coley, another artist blacksmith member of Intracoastal Iron, states the following about his artwork, "I made this piece while studying at Penland under Steven Yusko. My inspiration for this piece was capturing nature's beauty in ironwork."

Jason Cole. *Battered Hive Vase.* The outside is texture mild steel flowing upwards; the inside is perforated steel wrapped in a layer of copper. The vase is all held together by rivets with small spacers around the rivets between the bottom of the vase and the base. It all sits on rivet heads on the bottom, which make the two different parts of it look like it's floating. The size of the piece is 9 1/2" x 9 1/2" on the base. The diameter is 7" at the widest part and it measures 16" tall. *Photo, Eric Hernandez*

Richard Coley. *Roses in a Vase.* 2006. This piece is composed of mild steel. It is 18" tall at the tip of the roses. The diameter of the vase is 5 1/2". *Photo, Eric Hernandez*

James D.W. Cooper has this to say of his career as an artist blacksmith, "My name is James Daniel Webb Cooper; "Coop" for short. At fifteen, I started making jewelry in my parents' basement. My fascination with metal stuck, leading me to serve an apprenticeship in jewelry and silversmith work. A desire to make tools led me to blacksmithing. As a freshman at the Memphis College of Art, I was lucky enough to meet Mr. James Wallace, Blacksmith and Director of The National Ornamental Metal Museum. He made me an offer I couldn't refuse. He would teach me the craft, give me a room to live in, and occasionally a meal of macaroni & cheese, if I would work for him in the museum and do other chores, for no pay. His generosity changed my life. Through my years of association with the Museum and Jim Wallace ("Wally") I learned quite a bit and was privileged to enjoy many unusual projects in the Museum's Smithy. I helped restore the gates of "Graceland" after Jerry Lee Lewis crashed them with his Cadillac, restored the bronze sculpture of Elvis twice (his fans loved him to pieces), made numerous trophies for world renowned BBQ cookers, fashioned armor for an Etruscan warrior, repaired a national treasure for the Peoples Republic of China, helped create a silver tea service for the USS *Tennessee*, made a knife for the Governor, and jewelry for barnyard animals in Ireland and the USA. These are just a few of the adventures the pursuit of Blacksmithing has afforded me.

Ten years ago I left my career at the National Ornamental Metal Museum to establish my own shop. In those years I have made wedding rings, fountains for city parks, and many things in between. I never know what I'll find myself doing next. There is always something new to learn. Every project is a new adventure. That is why I love working in iron and any other metal. It may not be the surest path to riches, but it is a sure path to a rich life."

James D.W. Cooper. *Balance*. Forged iron, copper, river stones, forge fired vitreous enamels, die patinas, ferric nitrate, and copper sulfite patina. 8' l, 6' h. This weathervane sculpture addresses the delicate balance between industry and nature. The detail shots focus on the iron joinery and capture of the balance stone of "Balance" and the forged copper branch and leaves that counter balance the stone in "Balance." The leaves are colored with forge fired vitreous enamels and patina.

Maria Cristalli. *Wrought Iron Tree.* 2007. Forged and etched wrought iron.

James DeMartis. *Changing Seasons*. Iron, brass, and blown glass. 28" x 15" x 15". *Photo, Tim Lee*

James DeMartis. *Bouquet.* Iron and blown glass. 20" x 30" x 30". *Photo, Tim Lee*

James C. Dunmire explains how the circular sculpture came about, "Approximately ten years ago we visited De Leon Springs in Deltona, Florida, where a massive grinding wheel from a nineteenth century sugar mill was on exhibit. The wheel was 5' in diameter and had very large splintered, worn, weathered wooden paddles bolted to a heavy cast iron hub that together exhibited a ruggedness and rich patina that caught the eye and the imagination. My good wife has been after me for years to make a model of the wheel, so in order to keep the peace, I decided to give it a go."

James C. Dunmire. One-third Scale Model of the Sugar Mill Grinding Wheel. No forging, all fabricated steel. Center shaft is made from 2" OD steel pipe with steel hub transitions and 16 radiating steel ribs. Paddles were made from very old, weathered, raised grain, 3/4" wooden seat and back slats of a now deceased garden bench. A steel frame on the backside of the piece runs between the 16 ribs. The paddles are bolted to the frame with large, square-headed carriage bolts. After some experimentation, the enhanced, darkened finish on the paddles was done by dragging black liquid shoe polish from a deeply vee-grooved wooden paint paddle followed by a coat of butcher's wax. Piece is 22" in diameter by approximately 1.5" thick and is on permanent exhibit in our breakfast nook. *Photo, Janet Scalise of Integrated Communications Solutions in Chuluota, FL*

James C. Dunmire. Wall Sculpture. Hand forged and fabricated steel with silicon bronze highlights and combines geometric elements (twin tapering squares), with floral elements (1 center mounted flower with 6 large tapering leaves radiating from the twin trunks). 30" h x 20" w. This was made as a gift for my son in Winter Springs, Florida. *Photo, Janet Scalise of Integrated Communications Solutions in Chuluota, FL*

Mike Edelman designs and creates unique and high quality metal art. His work ranges from wearable art, to garden gates, to functional home furnishings. The artist stresses the latent fluidity in the metals and creates ultra contemporary designs through hot forging and fabrication processes.

Mike holds a BFA from Frostburg State University. He has entered numerous juried exhibits, and has work held by many collectors. He recently received a lifetime Juried Member status from the Pennsylvania Guild of Craftsmen, which is their highest honor. Currently, Mike is the resident blacksmith at Spruce Forest, an artist village in Grantsville, Maryland (www.spruceforest.org).

Mike Edelman. *Naveed Series: Woman Ripping Her Face Off.* Steel and copper. 14" x 6" x 4". *Photo, vibrant image*

Mike Edelman. *Bowl Form.* Steel and copper. 14" x 10" x 6". *Photo, vibrant image*

The Velvet Hammer's artist blacksmith, Roberta Elliott, discusses her abstract art. She states, "I call these pieces 'pods', due to their resemblance to seed pods. They are made from seamed black pipe. I first collapse the neck, leaving a bud at the end, which is flared into a flower. Next I punch a hole for its mouth, and finally neck down the base to establish its foot, which is rippled. I rub the completed pods with a brass brush for the finish.

Roberta Elliott. *Overture.* 16" x 8" x 4".
Photo, Larry Sanders

Roberta Elliott. *Hoodaloop.* 8" x 6" x 3".
Photo, Larry Sanders

Roberta Elliott. *It Takes Two.* 7" x 9" x 4".
Photo, Larry Sanders

Of her pursuit of her art, Rebekah Frank writes, "I fell into art by accident. I was finishing an Associates degree in Mathematics in California when I decided to take a couple of non-academic classes—welding and ballet. I didn't become a ballerina by any stretch of the imagination but the welding class definitely hit a nerve. I was nineteen. Currently I have found my place in the industrial world, working as a welder for the Applied Research Laboratory at the University of Texas at Austin. This frees up my creative energy to take the years of experience of working with artists and begin to establish myself as an artist in my own right. I am currently attending the Metal Arts program at Texas State University in San Marcos working towards a BFA in Studio Arts."

Rebekah Frank. *Medallions.* Forged steel and puddled copper, finished with oil. 12" x 12" x about 3" h. This piece was an exploration of geometric shapes. The frame and the inset forged pieces give a sense of motion to the piece. The simple form resembles the surface and shape of pollen grains, which have evolved to withstand the passage of time. The texture provided by the puddling of copper gives the piece an interesting contrast to the minimalism of the forged steel. The high points of the copper are polished to give further life to the piece. *Photo, www.onioncreekstudio.com*

Jim Gallucci has been the President of Sculptor Ltd. in Greensboro, North Carolina, since 1989. He has created over twenty-five works of public sculpture. His work has appeared in numerous exhibitions. Displayed here are two examples of his public work.

Jim Gallucci. *Mebane Library Books.* 2006. Bronze. Books range from 18" x 22" to 36" x 30". Installed Location: Mebane, North Carolina Public Library. Oversized books, some open, some closed, with various pages engraved. Tom Sawyer has the original manuscript engraved and Romeo and Juliet is in stage form. Client: City of Mebane, Alamance Arts Council.

Jim Gallucci. *Flutter Gate.* 2006. Galvanized steel. 10' x 6' x 3'. Green Hill Gallery. Beams reaching up and over to become fluttering pages of steel touching the ground.

Robert Garcia alternated between painting and sculpture, eventually merging disciplines, media and styles, exploring the best of both worlds. He states, "Life's experiences have taught me the value of creative improvisation. Metal forces a commitment to simpler, stronger, decisive form. I have never worked so hard to have this much fun!"

Robert Garcia. *Conversation.* Rolled 3/4" steel, cut by plasma, primed Por-15 rust preventive, top coat DuPont Imron polyurethane. 8'-4" h x 4' w x 6' d. Installed in Charlottesville, Virginia, at the ArtInPlace Sculpture Exhibition. This sculpture defines a space where viewers may enter, talk, relax, and look through the openings. Viewers' interpretations of this sculpture include: seed pods, sea shells, insect wings, angel's wings, people leaning toward each other, and a teepee.

Robert Garcia. *In The Mix* – Westgate Village Shopping Center – Toledo, Ohio. Steel. Triangular tapering tower supports spiraling wedges, accented with harmonious colors symbolizing the positive activity of freedom, celebration, and shopping! The busy shopping location called for a structure expressing lightness and optimism. 16' h x 6' w x 6' d.

85

Mindy Gardner became interested in chasing repousse, and the use of the treadle hammer (a foot powered hammer that allows a person to keep both hands free for work) after watching a demonstration by George Dixon in 1997. She describes her process as follows:

>The material I use is mild steel, usually 14 to 12 gauge. Using metal of this thickness gives me more metal to move and allows for more detail in my work. The majority of my work is wall hangings made to hang as scrolls or matted and framed with steel. The edges of the frames are upset to make them thicker. Other pieces are made as large coins also with the edges upset that are displayed on small easels.
>
>Before I start working the metal I anneal it three times in a coal forge, keeping the same side of the metal toward the fire at all times. This determines the scale pattern that will develop on the metal and that I use as part of the design.
>
>Chasing is working the metal from the front and is actually moving metal rather than removing it as you do in engraving. I use this technique to make lines for outlining, showing detail, showing depth, direction, and movement as you would use the lines in a drawing. The depth of the lines made in the metal works much the same way as the darkness of lines drawn on paper. The deeper the lines the darker and wider they appear and the shallower the lines the lighter they are. By the use of tools known as butchers and flatters, an object can be made to appear raised so I can give a layered look to the work. An example of this would be to show layers of leaves floating in a pond.
>
>Repousse is working the metal from the back side. I use this technique to push areas of my designs further out from the surface. This allows me to show more depth to my work and gives it the appearance of a relief. If an area is to be raised a lot, it is done with the metal hot and into a piece of wood, thus the detail is not destroyed. If it is to be raised slightly, it is done cold into a piece of lead for the same reason.
>
>After I am finished with the chasing and repousse work, I hand sand the pieces with 80 grit sandpaper to remove most of the scale and follow that with sanding with red 3M Scotch Brite™ to remove the scratches made by the sandpaper. I will leave scale in the metal in areas that I want to appear dark however. The areas that are brass colored are from a brass brush and then heated with a torch until I can get the color of 'gold' that I desire. The work is then waxed in Renaissance Wax."

Mindy Gardner. *Three Koi.* 12 gauge mild steel. Chasing and repousse technique, brass brush and torch (heat) color, Renaissance Wax finish. 14" h x 11 1/2" w x 3/4" d.

Mindy Gardner states, "The inspiration for the Three Koi wall hanging came from having a display of work at a Master Gardeners conference in Champaign, Illinois. The conference was a terribly boring ordeal, so I walked around looking at other displays. There was a Koi pond display and I spent a long time watching those fish as they swam around the small pond. … The Three Koi hanging is the result of a very boring day." *Photos, Mark Gardner*

87

John W. Gehl is a fourth generation metalworker. His great grandfather emigrated from Luxemburg and established a blacksmith shop in America. His family has been in the farm and construction equipment business for nearly 150 years. While John has had a long time interest in blacksmithing, it was not until he retired from the machinery business that he found time to devote to it. Guy Garey, a prominent artist blacksmith from Chestnut Tree Forge, Dunedin, New Zealand, further sparked his interest. John has also undertaken training at the John C. Campbell folk school.

John's materials are usually scrap steel, although occasionally new. Shapes and textures, as well as nature, inspire his creations. John's shop and studio, "La Perle Iron" in Manitowish Waters, Wisconsin, is well equipped, using both coal and propane forges, as well as a fly press and power hammer. Most of his pieces are private commissions, displayed in the homes of patrons.

John W. Gehl. *Curved Leaf 1 & 2.* 1/4" mild steel, deeply pitted and rusted. 18" h x 24" w x 8" d. each. The veining has been incised with a fly press. It was been formed in a coal forge, bringing out its shape characteristics of a leaf blowing about in Autumn. It is colored with burnt wax with a finish of bee's wax.

John W. Gehl. *Quarter to Twelve 1.* The core is heavily pitted steel plate with a formed and riveted base. The raised petals are light gauge sheet metal that has been flame colored. 20" h x 20" l x 12" w. at the base. This piece is a visual play on shapes and reflective characteristics.

89

Steve Hackbarth began his love of working as a smith thirty years ago when at the age of fifteen he first picked up a hammer to strike hot iron. At the age of twenty-one, Steve began working for Cedar Creek Forge in Cedarburg, Wisconsin. It was here that he says he received the bulk of his training as a smith. For the next four years, Steve worked for a Milwaukee based landscaping company in the summer months and for Cedar Creek Forge in the winter months. His duties at Cedar Creek included both production for the retail area of the shop and the filling of the smaller custom orders that were taken.

In 1988 he set his sights on setting up his own blacksmithing business- Badger Village Blacksmithing. He continued working as a blacksmith on a seasonal basis, producing ironwork during the winter and selling at art and craft shows throughout out the year. In 1990 he was accepted as an advanced student by internationally known blacksmith Francis Whitaker. "Working with Francis was a once in a lifetime opportunity and a very humbling experience. Here is this eighty something man that could out hammer someone one-third his age!" The project that he produced with Mr. Whitaker hangs on the door of the shop in Merrimac.

He moved his business to Merrimac in 1994 and within one year began producing two styles of faucet handles for Kohler Company; Finial Art-Wrought Swirl and Finial Art- Kudu. The handles have been used in Kohler Company ads in magazines such as Forbes, House Beautiful, National Geographic and Architectural Digest.

Steve taught blacksmithing at the Madison Area Technical College - Commercial Avenue campus from 1996 - 2000. He is a member of the Artist Blacksmith Association of North America, and the Upper Midwest Blacksmith Association. He has demonstrated at the John Michael Kohler Art Center in Sheboygan, WI, the Woodlake Markets in Kohler WI, and at local blacksmithing conferences. His work is in private collections in both the United States and England.

Concerning his artwork, Steve states, "The exciting thing about being an artist/blacksmith is that there is a seemingly endless array of possibilities for design along with an incredible number of items of all sorts that can be made, from napkin rings to driveway gates. It is this variety that always makes my work both interesting and challenging."

Steve Hackbarth. *Steel*. This piece was forged from a single piece of 1-1/2" round stock that began at about 28" long. It was inspired by the many "impossibly long" taper sculptures that have been completed by various artist/blacksmiths. 48" h. {above and opposite}

Steve Hackbarth. Steel, brass. This sculpture is an example of design by evolution. The initial idea was to produce a garden ornament that featured a stylized sunburst. As the layout work was being done, it seemed like it should really have a moon to go with it and then … Kind of like the book *If You Give a Moose a Muffin*. Approximately 80" h. {Details net page}

91

92

Working collaboratively, the husband and wife team of artist/designer/makers Tony Higdon and Erika Strecker created the impressive public art entitled Nexus.

Tony Higdon & Erika Strecker. *Nexus.* 2006. Fabricated stainless steel. 50' x 27' x 12'. Public Art commissioned by the State of Kentucky for placement in front of the New Transportation Cabinet Building in downtown Frankfort, Kentucky.

Frank Jackson writes that "growing up in the southeastern United States, nature was and is my greatest source of inspiration." That is apparent in his artwork presented here. Frank is a former bull rider who moved to California in 1988 and started shoeing horses and forging metal art. His work has been on display in numerous venues, including the Kentucky Museum of Art.

Frank Jackson. Life-sized Bull Skulls. *Photo, Frank Jackson*

Frank Jackson. *Hummingbird and Daffodil. Photo, Frank Jackson*

Frank Jackson. T-Rex Skull. This artwork is shown in front of Frank's barn studio. *Photo, Frank Jackson*

94

Benjamin Kastner is an artist blacksmith member of Intracoastal Iron. He states that is sculpture was produced during a fall study session at Penland.

Benjamin Kastner. Machete. 2007. Wrought iron, jail bar, and band saw blades were used to create this Damascus blade with 270 layers. 19 1/4" x 2 1/2" x 1/16" thick. *Photo, Eric Hernandez*

Jed Krieger, of Iron Wing Forge, created the following three sculptures.

Jed Krieger. Flying Form. Forged mild steel with raised copper, steel rivets. 54" l x 25" w x 13" h. This form is kinetic, hangs on swivels, and is designed to move with the air currents within a home or building. *Photo, Jeff Barger*

Jed Krieger. Bird Form Wall Hanging. Forged mild steel with raised copper inserts with copper/brass rivets. 30" h x 8" w x 10" d. *Photo, Jeff Barger*

Jed Krieger. Table Top Sculpture. Forged mild steel, raised copper, with steel rivets and elk antlers. 36" l x 30" w x 13" h. *Photo, Jeff Barger*

Artist blacksmith John Little has this to say about the detail of his Kingsburg wall sculpture, "The stylized boulder on right is a reference to a mysterious 125 ton boulder near my studio that sits on three 2" x 2" x 2" steel cubes."

John Little. *Sunset* Wall Sculpture. 2000. Forged and fabricated steel. 26" x 52" x 2". *Photo, J. Little*

John Little. Kingsburg Wall Sculpture. 2007. Forged and fabricated steel. Stylized waves crashing against the rocky coast of Nova Scotia near the town of Kingsburg, Lunenburg County. 27" x 42" x 3". *Photo, J. Little*.

John Little. *Tectonic Shift.* 2005. Forged and fabricated stainless steel sound sculpture with two 60″ stainless steel bows. Designed for musical and dance performance. 102″ x 132″ x 60″. *Photo, J. Little*

Manuka Forge. Sculpture. Hand forged mild steel with a wax finish. 14″ h.

W.R. Nager. *The Resurrection*. 2003-2004. Forged stainless steel. 28" h x 15" w. A simple, but elegant depiction of the Resurrection of the Christ.

W.R. Nager. *The Creation*. 2003-2004. Forged stainless steel and naval bronze. 28" h x 14" w. One of six designs produced to a doctor's office atrium in Sarasota, Florida.

99

John Medwedeff. *Combustion.* 2000. Forged and fabricated steel. Commissioned by the State of Illinois for the Southern Illinois University Carbondale Communications Building, Carbondale, IL. 8' x 7' x 8". *Photo, Jeff Bruce*

John Medwedeff. *Momentum*. 2004. Forged and fabricated steel. Southern Illinois University College of Engineering, Carbondale, Illinois, statewide competition. 15.5' x 17' x 9'. *Photo, Cynthia Roth*

John Medwedeff. *Parhelion*. 2005. Forged and fabricated steel. Commissioned by Carbondale Community Arts, Carbondale, Illinois, regional competition. 18' x 6' x 8'. *Photo, John Medwedeff*

Zack Noble. *Nodus #1.* 2006. Forged steel. 24" x 20" x 18".
Photos, Tom Mills

Robert W. Odom, Ph.D., has been a research chemist for the past thirty years and a metal artist for the last ten. Most of his work uses direct metal techniques. He states his sources of inspiration as follows, "I came to embrace this medium through two sources, one inspirational and one practical. My inspiration came from a 1997 Paris exhibit of the works of the French metal sculptor, César. I had never seen this type of direct metal sculpting in which the figure is formed form smaller pieces. ... My practical source is my good friend, William Sorich, of Los Altos, California. Bill is a master metalsmith and metal artist. He has shown me numerous techniques and introduced me to the wide range of tools employed in metal working."

Robert W. Odom. *Mona.* Mild steel. Finished with hard wax. 11" x 7" x 8". *Photo courtesy of George Young Photography, Palo Alto, CA. Printed with permission of owner.*

Robert W. Odom. *Otto.* Mild steel. Finished with hard wax. 21" x 20" x 8". *Photo courtesy of George Young Photography, Palo Alto, CA. Printed with permission of owner.*

Robert W. Odom. *Elle.* Mild steel. Finished with hard wax. 30" x 16" x 9". *Photo courtesy of George Young Photography, Palo Alto, CA. Printed with permission of owner.*

Robert W. Odom. *Breeze.* Copper. Natural and heat induced patina finish. 30" x 13" x 9". *Photo courtesy of George Young Photography, Palo Alto, CA. Printed with permission of owner.*

Regarding her artwork that has appeared in juried group exhibitions, artist blacksmith Lauren Osmolski states, "This most recent series of sculptures is inspired by the expressiveness of animals. Our desire as humans to transfer our emotions on to animals to communicate and understand ourselves is eternal. Transposing human and animal forms in design and myth has been employed by both ancient and contemporary cultures resulting in images that illustrate behaviors, convey emotions, and create identities. At times enigmatic, these forms resonate on an emotional level that transcends words and worlds. I am particularly interested in Northwest Coast Indian Art and the design principles of the Art Nouveau Movement. While very different from each other, they are both deeply informed stylistically by nature."

She continues, "Incorporating my earlier found object assemblage work with traditional metalworking I am finding a new voice as an artist. Through apprenticeships I have been trained as a blacksmith. In pursuing this applied art, I have found the scraps and leftover bits of metal, or sometimes the individual parts of another project, capture my imagination and identify themselves to me as potential components of new sculptures. The challenging engineering required to join disparate metals and materials inspires me. Working with a series, such as bird forms and mask motif, affords me the opportunity to explore all the different ideas that arise during the creation of a new piece. Through repetition I find inspiration."

Lauren Osmolski. *Winged Mask.* 2005. Forged steel, forged copper, copper wire. 23" x 9" x 9". *Photo, Ken Wagner*

Lauren Osmolski. *Grabby.* 2004. Forged steel, found steel, forged copper. 10" x 6" x 5". *Photo, Doug Yaple*

Lauren Osmolski. *Cairn.* 2004. Forged steel, forged copper, found cast bronze, wood. 29" x 6" x 6". *Photo, Doug Yaple*

Lauren Osmolski. *Raptor.* 2004. Forged steel, forged copper. 50" x 10" x 6". *Photo, Ken Wagner*

Lauren Osmolski. Untitled Steel Bird. 2007. Forged steel. 12" x 6" x 4". *Photo, Lauren Osmolski*

Albert Paley. *Sentinel.* 2003. Steel, stainless steel, & bronze. 73′ h x 30′ d. Installed at Rochester Institute of Technology, Rochester, New York. *Photographer, Bruce Miller*

John Rais Studios. *Disruptive Sky.* 2006. Wall vessel of forged and fabricated steel, patina, scorched paint. 38" x 26" x 11". The scorching of the painted surface was done using a MIG welder to spray molten spatter across the surface to burn the paint in a planned way.

David G. Robertson. *Genesis* Wall Sculpture. Forged and fabricated mild steel. 70" h x 20" w. *Photo, David Robertson {detail opposite}*

David G. Robertson. Table Sculpture. Forged and fabricated mild steel. 36" h x 14" w. *Photo, David Robertson*

111

Robert A. Rupert's makes the following statement about his work, "My passion for this trade started at an early age through my father. As the hot metal addiction grew, so did my circle of friends who had similar interests. In the late 1990s I became President of the Pittsburgh Chapter of ABANA, known as PAABA. As I sought to learn from others, I now teach to infect others into the trade that I love. I am currently working with materials received from the 9/11 ground zero site that will become commemorative rings for those fire departments who lost members in that 2001 disaster." Displayed here is Robert Rupert's ABANA 2006 Ring entry.

Robert A. Rupert. *Metal That Moves.* Forge welded iron ring with rotating stylized Seattle Space Needle. *Photo, Bob Rupert*

Displayed here are three of Heath Satow's works of art. He discusses each in detail:

Lizard Sculpture Project: Large abstracted rock formations made from rusted steel with stainless steel letters for the sign and plant forms. When viewing from straight-on, an image of a lizard appears among the otherwise seemingly random rock shapes. This effect of the lizard appearing with the viewer's motion around the piece mirrors the real-world effect of many lizards not being noticeable to the eye until they move.

Part of the attraction of this piece is that the typical viewer may not see the lizard upon their first site of the sculpture. Depending upon how observant they are, they may see it the second time they look, or the third, or not at all until someone else points it out to them. In this regard, it's a lesson in paying attention to your surroundings: looking for things you don't necessarily expect, something that we've largely lost as a species as we've lost touch with the need for those survival instincts so common in the animal world.

This sculpture is located on the corner of the development, situated at a 45-degree angle so it may be viewed clearly by passing cars and pedestrians.

The rock formations were fabricated from welded 10 gauge (slightly thicker than 1/8 inch) steel with a rust finish. All other pieces (the sign letters and "plants") were fabricated from 10 gauge 314 stainless steel with a grind finish. Letters of the sign are held off the surface of the "rock" with stand-offs to prevent any rust staining.

Heath Satow. *Ce N'est Pas Une Lizard.* 2006. Oxidized steel and stainless steel. 30' x 11' x 6'. Large abstracted rock formations made from rusted steel reveal an image of a lizard when viewed from a certain angle. Stainless steel is used for the letters for the sign and plant forms. When viewed from straight on, an image of a lizard appears among the otherwise seemingly random rock shapes. Located near a main entry point into the city of Palm Desert, California, serving as a sort of "gateway" piece.

Heath Satow. *Dream of Flight*. 2004. Stainless steel and stained glass. 32' x 23' x 23'. Permanent sculpture installation commissioned by the Raleigh-Durham International Airport. There are three eight-foot tall stainless steel sculptures on the floor, and 900 pieces of stained glass hanging from a 23-foot diameter stainless steel framework. The three floor mounted sculptures look up to the glass cloud above, envisioning themselves among the clouds.

RDU Sculpture Project: Dream of Flight is a sculpture intended to remind us of a time before we soared among the clouds. A time when our ancestors dreamed of reaching the heavens and, for us as children, the awe we had for flight before experiencing our first take-off.

The sculpture consists of three figures looking wistfully to the heavens, arms outstretched. Their reverent poses entice us to look with them at the sky above. As we gaze upward, their images materialize in the clouds.

Today, air travel is so common that we tend to forget what an amazing thing it is to fly. This sculpture will serve to remind us of the wonder and awe the sky held for us before we learned to fly.

The floor design is a globe expressed in shades of grey terrazzo. Anchored to this floor are three identical figures fabricated from 14 gauge 304 stainless steel with a patterned 40 grit grind finish. These sculptures each weigh approximately 160 pounds. Above these figures on the floor is a frame structure anchored to the center of the roof beams. Artist will consulted with the architect and the architect's engineer to determine design of anchor point. The frame has a trussed main structure fabricated from .25 inch diameter solid 304 stainless steel rod. This entire structure has a brushed finish.

Suspended from this frame is 900 pieces of waterjet cut stained glass. Of these, 2/3's are light blue streaked glass and 1/3 uniform cobalt blue.

Denver Zoo Sculpture Project: Twenty-two life-size animal sculptures created for the Denver Zoo. A range of animals, from impalas to giraffes, grace the new entry plaza. The plaza opened to the public in 2004, and these sculptures are seen by over 1.5 million zoo visitors each year. All the pieces were fabricated from stainless steel, then treated with a unique ferric oxide patina created specifically for this project.

The real trick with this project was meeting two distinct needs, seemingly in opposition. The zoo wanted to do something unusual for a zoo; they desired abstracted animals, rather than the traditional approach of realistic bronzes. On the other hand, since a zoo *is* a place of learning (where hundreds of thousands of school children visit each year), they wanted the animals to be *accurate.* This presented quite a challenge – distill the animal forms down to somewhat abstracted gracefully curved, faceted surfaces, while retaining quite accurate overall dimensions and shape. By working closely with an exhibit design firm that works closely with the zoo (www.ecos.us), I was able to create designs that pleased even the zoo director, who was slow to come around to this more contemporary approach. The final result was one that pleased everyone from the traditionalists and animal experts to the lovers of contemporary art.

Heath Satow. *Giraffe Calf and Mother.* 2004. Stainless steel with oxide patina. 9' x 10' x 10' (life size). These are two of twenty-two life-size animals installed in the main entry plaza of the Denver Zoo. All animals are life-size and accurately proportioned to real animal anatomy.

Heath Satow. *Giraffe Family.* 2004. Stainless steel with oxide patina (life size). Animal sculptures for the Denver Zoo.

Heath Satow. *Giraffe Bull.* 2004. Stainless steel with oxide patina (life size). Animal sculptures for the Denver Zoo.

Susan Schultz, of Sandusky, Ohio, has designed sculptures in stainless steel and steel but has also worked with ceramics, glass (hot and cold), wood, photography, painted in oil, and watercolors. This sculpture, The Path to Freedom, was commissioned by a local organization with a limited budget to design and produce a sculpture for the Sandusky community. I tried to think of a way to do something the community could help with. A sculpture design containing a little bronze and about 800 feet of welded chain was the result. Mike Sohikian did the pour for the bronze. The chain bodies were shaped around wooden molds, which were burned away when the chain was in place.

The sculpture is life-sized and made primarily with 1/4" grade 43 high test chain, shot peened with a working load limit of 2600 pounds and bronze. The weight of the arm was counterbalanced by making a wing truss in the chest wall out of welded chain so the support would not show.

The "Path to Freedom" stands at the foot of Hancock Street in one of Sandusky's parks, "Facer Park." Susan has this to say about the artwork: This sculpture represents a black family crossing the plane to freedom. By depicting a man who is not starving, is clean shaven, and has a hair cut of today, my hope is for people to ask themselves: "Has the black family truly crossed that plane today?" and if not, "Am I helping or hindering the transition?"

Our community strove to support an ideal in the past. We have continued this ideal by presenting this sculpture as a combined effort by the citizens of this community. Listed below are the contributors who through donations of funds and/or their contribution of time have made this installation possible. Thank you! Susan Schultz – artist.

Susan Schultz. *The Path to Freedom.* 2007. Chain and bronze. While the burn was taking place, I photographed the bronze face of my classmate in the waters of Lake Erie. This is the lake Sandusky residents helped the slave escaping to freedom to cross.

Susan Schultz. *The Path to Freedom.* 2007. Chain and bronze. Patina: A patina was produced by heating the surface of the bronze and applying Potassium Sulfide (Liver of Sulfur). The bronze was neutralized with water and then the patina on the outer surfaces was taken down with a kitchen-scouring pad. Finally, Ferric Nitrate was sprayed on to give the golden brown tone to the skin. After the bronze was neutralized once again, the sculpture was heated and wax was applied and then buffed to a shine.

Susan Schultz. *The Path to Freedom.* 2007. Chain and bronze. Burn: After the chain was welded, we had a ceremonial burn on my beach. The Sandusky Fire Department and neighbors attended.

Susan Schultz. *The Path to Freedom.* 2007. Chain and bronze. Placement: After the family was welded together and mounted on the steel base, the men from MACK Iron and the Sandusky Parks Department transported the sculpture to the final place prior to the dedication.

Susan Schultz. *The Path to Freedom.* 2007. Chain and bronze. Night Sculpture. *Photo, Mike Pizarski – Director of Sandusky Parks and Recreation*

Susan Schultz. *The Path to Freedom.* 2007. Chain and bronze. *Photo, Terry Seagert photographer*

119

Graeme Sheffield is a self-trained artisan blacksmith. Graeme's history of working with metal has evolved over the years. He has gained knowledge and experience with design, function, and form through designing and fabricating custom automation machines. He has taken his years of acquired metalworking skill and enjoyment of the discreet fluidity of steel to an artistic level, and uses these skills to his advantage when creating custom blacksmith pieces for his clients.

Inspired by the natural world around him, Graeme hand forges original pieces out of steel, displaying the strength of the medium, yet the delicacy of the hammer.

Of his work, Graeme states, "I realized that I was looking for a way to express myself artistically, and working with metal seemed to be the natural course to take. The art of blacksmithing allows me to interpret the lines, forms, and textures I see around me in this world, and express myself and my observations through the use of some of the very core elements of the earth (iron, fire, water). Participating in, and constant exploration of, such an ancient craft as blacksmithing holds a great deal of mystique and adventure to me. Having the ability to create items using the same basic tools and techniques that have been used for centuries is a thrilling experience. When a piece of steel is heated to yellow-hot (around 2000 degrees F), it is then that the magic begins for me. It is then that I am able to shape, move, and manipulate the steel into forms that bring it to life. It is truly a pleasure to take an otherwise cold, lifeless medium as steel and transform it into an object that allows people to appreciate its flexibility, strength, and limitations at the same time."

Graeme Sheffield. *Delicate Balance.* 2007. Forged metal tube and stand. This piece was created for the 2007 Red Ribbon Gala Auction, a fund raising gala event for the AIDS Committee of Guelph, Ontario, Canada, and the Masai Centre for Local, Regional, and Global Health.

Graeme Sheffield. *Royal Friendship.* Forged metal "crown" and blown glass friendship ball. "Metal and glass show so well together."

John Boyd Smith. *Wild Geese – Kilkenny, Ireland.* Forged from mild steel. Stands over 8' h. Weight: approximately 800 lbs. The sculpture depicts two realistic and life-sized Canadian geese in flight. This piece is currently being exhibited at the National Craft Gallery of Ireland in Kilkenny, Ireland.

Of his sculptural work, artist Mike Sohikian states he uses A 36 steels, recycled steel. He achieves his patinas by sandblasting and natural weathering. He rubs motor oil or similar oils into the surface periodically.

Mike Sohikian. *Giraffe.* A36 steel and glass. 6' x 9' x 3'.
Collection of Dr. Greoor K. Emmert, Perrysburg, Ohio

Mike Sohikian. *Ponder En Peligro Especit*. Rectangular steel tube, steel, cast bronze. 9' x 7' x 4'.

122

Mike Sohikian. *Variations of Matisse.* Steel and concrete. 4' 6" x 25' x 6'. *Collection of The Village of Ottawa Hills, Ohio.*

Mike Sohikian. *Feeling the Changes of the Moon.* Steel, aluminum, cast concrete. Kinetic sculpture. 6' x 4' x 4'. *Collection of Nancy Weaver, Charlie Mahjoobi, Arlington, Virginia*

Erika Strecker designed and created this hallway niche sculpture for the Jewish Hopsital Medical Facility of Louisville, Kentucky. The Nouveau Dragonflies wall hanging is accompanied by her hand-forged ginkgo towel bars.

Erika Strecker. *Winter Solstice of the Ginko – Rebirth of the Sun.*
2006. Hand forged steel and bronze. 3' x 3' x 8'. *Photo, Erika Strecker*

Erika Strecker. *Nouveau Dragonflies.* 2003. Hand-forged steel, copper, and bronze. Private residence. 3' x 5' x 4". The hand-forged ginkgo towel bars are located to the left of the artwork. *Photo, Greer Photography*

Scott Sweebe reflects upon his career and his art, "I started working metal as a high school sophomore because there were things I wanted and that was the only way I could afford them. In the ensuing decades, I have made items that were totally practical and needed, practical and wanted, impractical and wanted, and completely impractical, fantasy art pieces. Using minimalist – frequently almost primitive – tooling, my ever-growing skills have enabled me to be in numerous shows and exhibitions. I have also been published in a couple of field related journals.

I believe art should be more than something hung on a wall. It should be part of normal life and appreciated every time it is used. As an artist, I work to create pieces that evoke shared memories and experiences."

Scott Sweebe. *Capsicum.* 2000. 0.065" thin-walled mild steel tubing. A string of drawn, fullered, upset, and swaged chilies. 5" x 9" x 0.5". *Photo, Scott Sweebe*

Patrick Terry and his wife Patricia operate Gatekeepers artist blacksmiths, a metal design firm located in Oregon City, Oregon. Of their work, Patrick states, "Trish and I spend a lot of our creative time twisting different shapes with a lot of heat, and a lot of force. The effect is truly inspiring. The metal flows differently every time due to the locked up energy within the piece. Unlock that energy, and the metal will flow like water until you tell it to stop."

Patrick & Patricia Terry. Water Fountain. Stainless pipe polished to no. 8 mirror with water flowing. Private commission.

Patrick & Patricia Terry. A gallery piece. Steel sheet, heat tint patina with clear powder coat. 5' h x 2' w.

David Thompson has been forging sculptural art since 1979. His most recent piece, Marker of Origin, is a thirty-foot tall forged tower covered in ceramic tile, made in collaboration with ceramics artist Betsy Wolfston. Since 1985, David has completed fifteen public art commissions in Columbia, Missouri, Aachen, Germany, and throughout the State of Oregon.

David states that he plans to teach forging workshops, spend more time on furniture, garden art, and table top sculpture. He has taken part in numerous exhibitions over the years.

David Thompson. *Rainforest.* 1990. Fountain of copper plated forged steel pipe and hand placed aggregate stone concrete. 8' h x 10' w. This fountain was David's first public art commission. It is located in the interior courtyard of the Lane Transit District Administrative Office Building in Glenwood, Oregon. The fountain involved the most elaborate engineering of any of David's public art projects to date, since each pipe had to have the correct slope so that the water would drain properly into the grate. *Photos, Rebecca Ellis.*

David Thompson. *The Promise Tree.* 1998. Forged steel and copper. 8' h x 8' w. Commissioned by Lane Educational Development for the Student Achievement Convention. Forged steel and copper hands for leaves with a concrete base. Students participating in the convention made a commitment to the environment, stamped their names and ages on one of the 1500 copper leaves, and attached them to the tree. This piece is located at the Convention Center at the Lane County Fairgrounds. *Photo, Rebecca Ellis*.

David Thompson. *Marker of Origin.* 2006. Forged rails, ceramic tile, and terrazzo cement on an 8' octagon concrete base. 30' h x 8' w. This piece replaced a fountain that was originally part of the exterior of the Eugene Train Station. When a renovation was completed in 2006, the City of Eugene Percent for Art contracted David and ceramic artist Betsy Wolfson to design a marker. *Photo, Rebecca Ellis*.

David Thompson. *Nest.* Weathered steel. 95" h x 114" w. The quiet, birdlike forms suggest a place of refuge, reflecting the continuum of life from birth to death. This piece was designed from a small forged maquette, which allowed David to directly move the material. It was later fabricated on a larger scale using sheet metal. *Photo, Rebecca Ellis*.

Of his forged sculpture, David states, "These are one-of-a-kind forged sculptures. I start with an interesting piece of industrial scrap and see where the process takes me, there are no preliminary drawings. With heat, the material becomes plastic and I work to free the spirit from the material."

David Thompson. *Cosmopolitan Woman.* Forged steel with a painted steel base. 20" h x 9" w. *Photo, Rebecca Ellis*.

David Thompson. *The Last Californian.* Forged steel. 35" h x 8" w. *Photo, Rebecca Ellis*.

Ira R. Wiesenfeld states that his sister was the family artist, while he was the family scientist. However, in 2002, Ira sold his veterinary practice and began forging full time. He states, "To prepare for this transition I studied art and sculpture at Pima Community College, Tucson, Arizona, and read extensively. I am a member of the Artists Blacksmith Association of North America (ABANA) and Vice President of the Arizona Artist Blacksmith Association."

Ira R. Wiesenfeld. *My First Treehouse.* 2007. Forged and welded steel. 39" x 31" x 21". *Photos, Jack Kulawik*

Mike Wolfe has this to say about his sculptural art, "Working at the forge and anvil since 1986 has allowed me to capture the natural look of flowers in steel. Nature has been my inspiration from the swampy iris in the wetlands to the rose of the well-tended garden. Though the flowers are made of steel and hard to the touch, with fire and hammer as the tools, my work reflects the delicacy and movement inherent in nature's design. I share this garden with you."

Michael Wolfe. *Maple* Wall Hanging.

Michael Wolfe. *Iris.* Bronze.

Chapter 6
Furniture

Bending, shaping, and welding wrought iron into furniture has a long and storied history extending back to the old Roman Empire. Today furniture handmade by artist blacksmiths is quite popular and takes on many forms. Outdoor and indoor furniture is being made, including couches, chairs, stools, headboards, desks, table bases, etageres, and a variety of innovative racks. The influence of both the Art Nouveau and Art Deco movements are often found among today's artist blacksmith created furniture, along with very traditional design elements. As the years go by, artist blacksmiths continue to find new approaches that keep the innovations in their furniture moving forward today.

Jeffrey L. Wallin. *Tsunami Table.* Mild steel. *Photos, Keith Cotton/Keith Cotton Photography*

Tables

Jeffrey L. Wallin lives and works in Memphis, Tennessee, as a blacksmith at the National Ornamental Metal Museum. There he works on commissioned ironworks ranging from architectural to sculptural. Jeff explains his work as follows, "My own work usually centers around functional objects, such as furniture, albeit with a definite sculptural bent. During my time spent studying blacksmithing at Southern Illinois University in Carbondale, I developed a body of work dealing with contemporary design elements, but focusing on traditionally based joinery techniques. These traditional techniques often took on a new life as I explored the limits of just what 'traditional' meant. To me, joining something without a welder (or bolts) places it firmly in this category."

Jeffrey L. Wallin. *Confluence Table.* Joinery detail. *Photos, Keith Cotton/Keith Cotton Photography*

Jeffrey L. Wallin. *Confluence Table.* Mild steel. *Photos, Keith Cotton/Keith Cotton Photography*

Jeffrey L. Wallin. *Confluence Table.* Joinery detail. *Photos, Keith Cotton/Keith Cotton Photography*

Bill Howard has been working in metal for forty-two years. He is the headmaster of the Howard Academy for the Metal Arts. Here he artfully joins iron and oak to make a striking table.

Bill Howard. Table. Iron and oak with red stain.

David Thompson. Dining Table. Forged steel and glass. 42" glass top.

David Thompson. Coffee Table. Forged steel and glass. 15" x 25" x 48". *Photo, Rebecca Ellis*

David Thompson. *Aloe Vera Table.* Forged steel and glass. 16" x 28". *Photo, Rebecca Ellis*

Brian Gilbert. Coffee Table. 2002. Mild steel, glass. I built this table for my mother, Marge Hardin, who died early this year. 52"L x 16"w x 17"h. *Photo by Sandy Andrews*

Jeff Benson. Bronze Leaf Table. Forged mild steel, bronze, and glass. Dramatic table with winding leaves in plain view beneath round glass top. Sturdy legs rise with strength and grace. 48" x 32". *Photos courtesy of Ryan Commercial Photography*

Brian Gilbert. Marble Pedestal Table. 2000. Mild steel and marble. These tables are designed to use individual marble floor tiles as table tops. I've made several using this basic theme, but each has different design elements... vine-like twists, leaf forms, or other forged effects. 12"l x 12"w x 28" tall. *Photo by Sandy Andrews*

Jeff Benson. Art Nouveau Table. Heavily forged mild steel, topped with 1/2" glass. Table design inspired by the Art Nouveau period. *Photos courtesy of Ryan Commercial Photography*

Rachel and Timothy Miller. Dogwood Table. Hand forged steel with heat patinated copper accents. The flowers on this table are copper that is heated to a precise temperature to create an intense purple hue. 36" h x 18" d x 48" l. *Photo, Bob Barrett*

Rachel and Timothy Miller. Leaf Table. Hand forged steel with copper textured base. The leaves on this table were created using chasing and repousse techniques. 36" h x 36" w x 18" d. *Photo, Bob Barrett*

Rachel and Timothy Miller. Magnolia Coffee Table. Hand forged steel with bronze accents. This table employs traditional mortis and tennin joinery as well as modern welding techniques. 20" h x 18" d x 40" l. *Photo, Bob Barrett*

Wayne Henderson discusses his journey into the world of the artist blacksmith, "In waning years of the last millennium, my creative interests began to shift from an irrational exuberance for electronic art to a love for the age-old medium of metal. While I had had a successful career as a freelance graphic designer enjoying the challenges of such projects as interface design for virtual reality rides at Disney's Imagineering, increasingly something seemed lacking after the computer was shut down. My work disappeared with the last flicker of the flat screen.

I was yearning to hold something in my hand at the end of the day. Some object that would bring me more joy than working for eight hours rearranging pixels on screen. One day while I was seeking out other mediums to explore, a friend told me about the local vo-tech high school's course in welding. On the first night of metal shop in 1999 when I struck up an oxyacetylene torch and put it to steel, I also struck up a love affair with metal. A few years later I took a blacksmithing course at the John C. Campbell Folk School in western North Carolina and discovered the joys of moving and shaping metal at the anvil. I was definitely hooked.

I continued taking blacksmithing courses and slowly began acquiring the basic equipment needed for the craft. In 2002 I moved from northern Virginia to Chapel Hill, NC where I set up shop to earnestly explore the mysteries and challenges of metal. And while it has been a nosebleed learning curve to say the least, at the end of each day I can now hold something in my hand. And that, in and of itself, gives me great satisfaction."

Wayne Henderson. *Protecting Her Clutch* Hall Table. 2007. Mild steel with a brass brush, clear coat finish. 28" h x 15" d. (20" d glass top). The design elements, which make up this piece, tell the story of one brief moment in time. The wings and body of a stylized butterfly form the top of the table. The insect has just landed on a small sphere held up by six blades of grass. Wrapping around the sphere is a mother snake whose clutch of eggs is nestled within the blades below. Her tail has quickly wrapped around one of the butterfly's legs and her head is moving towards another. The butterfly has intuitively drawn back another of its legs to strike at the approaching snake's head. While this scene is obviously improbable, it does suggest what happens in nature every day. While we see butterflies, birds, squirrels and other creatures flitting about our yards in a seemingly harmonious way, other creatures see them as attackers or as prey. And it is those twin realities – that nature can be beautiful and violent – which grounds me and reminds me that I too am simply an animal living in a fragile world.

142

Rebekah Frank. Shepherd's Crook Table. Forged steel, forged copper, steel rivets and glass top. 18" x 36" with 36" d glass top. This three-legged cocktail table has hand forged octagonal legs tapered to a point and curved into a shepherd's crook. The feet also continue the eight-sided theme. With the copper scrolls facing into the steel shepherd's crooks, a simple design has an interesting focal point to draw interest to the piece.
Photo, www.onioncreekstudio.com

Mark and Mindy Gardner. *Leaves and Pond Snakes Table.* 2006. Mild steel. The hand forged table base was made by Mark Gardner using traditional joinery methods such as mortise and tenon joinery and slitting and drifting. The table top was made by Mindy Gardner using chasing techniques. The legs are made of 5/8" square stock, cross braces from 1/2" square stock, top braces from 1/4" x 1" flat stock, and snakes from 1/2" round stock. The top is 3/16" plate. 23" h x 23" w x 23" d. *Photos, Mark Gardner*

146

Ira R. Wiesenfeld. Nest Console Table. 2006. Forged and welded steel, mesquite, turquoise. 37" x 48" x 13". *Photos, Jack Kulawik*

Ira R. Wiesenfeld. Mesquite Bean Table. 2005. Forged and welded steel, mesquite. 25" x 32" x 22". *Photo, Jack Kulawik*

Douglas Randall Thayer has this to say about his work as an artist blacksmith, "If we and future generations are to survive on this earth, we must conserve and preserve. Conserve the remaining natural resources that are used to get us through everyday life and preserve the old methods, crafts, structures, and machinery that helped get us where we are today. In my work as an artist blacksmith I try, whenever possible, to re-use steel and other materials such as glass. Some of the old steel pieces such as gears or wheels or parts from old farm implements were a part of machinery that was used to build this country. Although some of my methods and machinery may be more modern than a blacksmith of one hundred years ago, I still strive to learn and preserve the old ways and methods and to gather and preserve the old machinery that would have been used in a smithy years ago. And if, as I travel this chosen path, I am able to teach and pass along what I have learned, then I will be satisfied in knowing that I may have done my part to ensure that future generations will survive."

Douglas Thayer, Webberville, Michigan. Coffee Table. 2007. 28" x 37" x 18". The tempered glass is 3/8" thick. The flowing form of the legs and the suspended frame make this work attractive. This table is produced of mild steel, heated and hammered to produce a texture. The legs were formed not by using a bending jig but by forming the first leg half and then marking the layout on a steel table with soapstone, then heating and freehand bending each piece to fit within the layout. Each leg is made from two pieces (very close to being identical) that have a leaf drawn and hammered on the upper end of each and about twelve inches of bar drawn out to wrap onto the rectangular frame. The rectangular frame is made of four separate pieces, joined at the corners with forged brackets riveted. The stretcher under the table forms a friendship knot in the center and is joined to the table legs by welding. The welds were then wrapped with round bar. My client wanted the glass to set within brackets rather than having it just sit on top loose, so brackets were forged to hold the glass in place and to fit the curve of the top of the legs. The glass was a second hand shop find and appeared to be tempered glass. To finish this table it was wire wheeled then sprayed with several coats of matte lacquer. *Photos, Douglas Thayer*

James D.W. Cooper. Neo-Celtic Console. Forged iron, Granite, Faux finish. 32" h x 48" l, 15" d. Piece commissioned by private collector. *Photo, James D.W. Cooper*

John Boyd Smith. *Savannah Lowcountry Table* – Kilkenny, Ireland. The "Savannah Lowcountry Table" is forged from mild steel and realistically depicts egrets, mangrove vines, ferns, marsh grass, cattails, palmetto palm fronds, and other flora indigenous to the southeastern marshlands. The table is 30" deep, 84" long, 42" high, and weighs approximately 600 lbs.

Tessa Wittman moved from Maui to North Carolina in the spring of 2006 to pursue her love of blacksmithing. She spent two years working and learning at Penland School of Crafts. Her body of work includes jewelry, tools, functional and sculptural pieces, and architectural installations. At the time of this writing, she lives and works in Bakersville, North Carolina.

Of her work, Tessa Wittman states, "I thrive on the juxtaposition of masculine and feminine. I play with heavy, emasculated processes to produce soft, feminine lines. Steel is a balance of these opposites, strong and solid when cold, soft and playful when hot.

Joinery is the most intimate aspect of blacksmithing. A fire-weld is the most compelling connection in which different pieces of steel are fused via heat and force. My love of these joins inspires intriguing and beautiful solutions to assembly in the designs I create."

Tessa Wittman. Table with a Gun. Mild steel, cast glass, glass. 16" x 27" x 17" At the time, this was the largest and most complicated piece I'd tackled. Without Toby Hickman's guidance, I would still be sorting out the joints! *Photos, Mary Vogel*

Neil Mansfield first developed a passion for working with both hot and cold steel during my years in vocational high school in New York City. Today, Neil owns and operates a small one-man blacksmith studio, Flying Sparks. He blends his technical background and design skills to creative functional metal work that is pleasing to the eye. Neil states, "My enjoyment in moving metal is reflected in my work, in which I combine iron, bronze, copper, and stainless steel to produce unique objects such as furniture, garden gates, railings, fireplace accessories, and decorative metal art. The marriage of metals gives me the opportunity to experiment with color, texture, and shape."

Neil Mansfield. Table. Black iron, bronze, forged and fabricated. 30" h x 20" d.

Dietrict Hoecht, of Big Bang Forge Inc. in Clayton, Georgia, strives to infuse my metal shapes with the joy of creating unique objects, emphasizing aesthetics, special visual accents, different materials joined together and professional execution. Of his end table, Dietrict states, "A fellow, who has one of those large outdoors band saws, showed me to his junk car and opened up the back door. He had several slices of a curved cherry trunk in his 'drying chamber'. Of course, I bought three of the slabs.

Well, this piece of tabletop wood lends itself to creating something within the crescent-shaped empty space, which is evident if the table sits against a wall. *Voilà le end table*.

I formed two roses, one for underneath the table, up front, and the other one appearing above the table top from behind. The blossoms are made of silver leaves, which are left dull and unpolished the way they come out of the acid pickling bath. The rose calyx and sepals are formed from copper sheet and patinated green, while the iron leaves received a mottled flame enameled surface.

For shaping the four legs I had built a special hydraulic compression fixture. It uses a series of toggle clamps to hold a piece of pipe in place, while a hydraulic jack exerts compressive force on this column. The pipe has been fullered down at intervals to create a sausage row appearance. When compressed in a red-hot state it deforms having bamboo-like narrowed sections and knots. At the same time it may also buckle out sideways a bit, taking on a natural character, as seen in the picture.

I kept the table stiffening reinforcements to a minimum to let the cherry top and the roses speak loudly."

Dietrict Hoecht. Rose End Table.

M. Craig Campbell. The Oval Office Table. 2006. Steel, clear paint/clay, glaze, forged steel/architectural ceramics. Collaborator: Ken Wilkinson (ceramic artist). 30" h x 34" w x 22" d. *Photo, Trent Watts*

M. Craig Campbell. Wrought Cherry. 2006. Steel, clear paint/cherry wood, oil, lacquer, forged and fabricated metal. All joinery is traditional mortise and tenon or rivets. The 1 3/4" cherry top tilts from flat to 25 degrees and can be locked anywhere in between. The top was commissioned from Arthur Perlett, a Saskatchewan furniture artist. 36" h x 62" w x 31" d. *Photo, Trent Watts*

M. Craig Campbell. Sofa Table. 2003. Mild steel, paint and varnish, forged and fabricated. Collaborator: Miranda Jones (paint and metal artist). 30" h x 54" w x 14" d. This table was a collaborative project with Miranda Jones of Saskatoon. The top was plasma cut from 1/4" plate. The two matched legs were sectioned from 4" diameter pipe, which was flared to 8" diameter on the bottom and narrowed to 2" diameter on the top. The third leg is 38" long and was forged from sixteen inches of 1 1/2" square bar. All three legs were welded to the underside of the tabletop. A custom fit 3/8" thick glass top finishes the piece. *Photos, Hogarth Photography*

Seating

Ira R. Wiesenfeld. *Shotgun Rocker.* 2006. Found and forged steel objects, welded. 42" x 23" x 40". *Photos, Jack Kulawik*

Ira R. Wiesenfeld. *Rockin' in the Shade.* 2007. Found and forged steel objects, welded. 84" x 30" x 56". *Photos, Jack Kulawik*

Dietrich Hoecht. Bar Stool. The seat is made from a branching pecan trunk slice and screwed atop a heart pine vertical. Its foot is jammed with wooden wedges between two circular receptacles in the center of the iron base.

Rachel Miller. *Dogwood Chair.* Hand forged steel, textured aluminum, and heat patinated copper. 64" h x 16" w x 16" d. The inspiration for this chair is the transition between winter and spring. The coolness of the aluminum represents the stillness of winter and the flowering branches represent the emergence of spring.

Rachel Miller. *Spring's Throne.* Hand forged steel, stainless steel, and copper. 5' h x 18" w x 18" d. This piece was designed to celebrate the coming of spring after a long, hard, cold winter in the shop. It was intended to be my personal "rain dance" in hopes for some warmer weather.

Mike Edelman. *Entry Chair.* Steel and red ultra suede. 48" x 20" x 18". *Photo, artist*

Mike Edelman. *Entry Chair #2.* Steel and red ultra suede. 49" x 19" x 18". *Photo, vibrant image*

Mike Edelman. *Entry Chair #3.* Steel and red ultrasuede. 52" x 22" x 20". *Photo, vibrant image*

Mike Edelman. Bar Stool. Steel and ultrasuede. 40" x 16" x 14". *Photo, artist*

James D.W. Cooper. *Tomato Chair.* Forged stainless steel and copper, colored with chemical patina and vitreous enamel (enamels fused in the forge). 4' h, 16" seat height. This piece is a garden seat, celebrating home-grown tomatoes.

James D.W. Cooper. *Forest Throne.* Forged iron, forge fired vitreous enamels, jute rope, faux finish. 6' h, 17" seat height. This piece celebrates the woods near my home.

James D.W. Cooper. *Penland Bench.* Forged iron, Cypress wood. 8' l, 20" w, 18" h. Commissioned piece for the front porch of a dormitory at the Penland School of Crafts, Penland, North Carolina.

James D.W. Cooper. *Sun Throne.* Forged iron, silk fabric. Flowers are colored by brushing the heated iron with a brass brush. 5' h, 16" seat height. This piece is a celebration of my favorite summer flower.

Todd Campbell. Chaise Lounge. 2006. Forged steel in a contemporary style with microsuade upholstery. Created for "The Floating Chair" show in Austin, Texas. It was purchased for a private residence. 30" x 72" x 36". *Photos, Todd Campbell*

John Rais Studios. Bench Seat. 2003. Forged and fabricated steel, bronze plating. 20" x 72" x 18". This piece was designed and created for a private residence outside of Philadelphia, Pennsylvania.

Erika Strecker. *Tulip Poplar Bench.* 2007. Steel. Woodland Park, Community Flower Garden, Lexington, Kentucky. 6' x 5' x 20". *Photo, artist*

Beds

W.R. Nager. Iron Bed. Forged iron king-sized bed. Tampa residence.
Photo, Dave Morrison, Photographer

Dietrict Hoecht explains his "Cultured Day Bed:" "We had built our dream home in timber frame construction. The timber bents span 28', and this created a large open space between the kitchen area, the fireplace, and the large French doors toward the outside deck. We needed a comfortable seating area, but had trouble envisioning a typical sofa, which inherently poses the blocking and unsightly feature of the backrest, when viewed from the other side. So, my wife and I went shopping for a free shape sofa or day bed without back, on which we could use large pillows to rest against. However, we found nothing to fit our taste or the ambiance of our living space. Hence, the executive decision was made to tackle my own design.

After we had bought a mattress with the right softness I started with five two-wheel swivel casters which would not mar our wood flooring. The rectangular bed frame was created out of 1 3/4" x 3" aluminum tubing, and I laid a sheet of plywood over it. Since my wife insisted on avoiding sharp corners I designed a rectangularly shaped bed with curved head and footboards. The iron head and footboard needed to display an open structure with few structurals and just enough curls and spirals to keep the pillows in place. To make things fit properly a three-dimensional full-scale layout was needed. I like to combine different metals and also use found wood from the forest behind our house.

The four corner posts were made of vine choked curly small tree trunks, topped with half-decomposed heart pine knots as finials. For the rails of the head and footboard I thought of cutting and bending in place suitable small diameter green muscadine vines. Freshly cut vines have coarse capillaries and are dripping full of sap, and I expected them to bend easily. However, this task turned out to be 'wrestling with giants', but I did not want to go through the trouble of steam bending the wood. So, the rails were sequentially bent and twisted with brute force, one mounting point after the other and screwed against the iron stanchions.

All of these rail mounting points and the tack welded joints were wrapped with copper wire. I patinated some of these wraps blue with ammonia vapor. It was rather difficult keeping the aluminum foil

covering in place for a couple of hours to get the bluing effect, but it turned out pretty nice. Some of the iron leaves received a color touch from a bit greenish flame enameling.

Lastly, the sofa bed became wired and 'electrified', so that we could comfortably use a built-in reading lamp. The lamp mount and two supports for drinking cup receptacles move on double linkages for convenient reach and 'luxurious leisure lounging'. My wife had produced the recessed receptacles and matching mugs in her pottery.

Certainly no such day bed could be found in a store, and it now fits harmoniously in our spacious living surrounding."

Dietrict Hoecht. *Cultured Day Bed.*

Greg Price. Dogwood Headboard. Mild steel. Posts 1-1/2" square, center oval 3/4" square, collared oval and cross bars 1" square, hand hammered texture, mortise and tenon joinery, overall dims. 79" w x 72" h, center oval is 31" on the long axis, leaves and blossoms were lazer cut then hand textured and veined in a coal forge, hand sanded with hand rubbed oil wax finish. Private residence. *Photos, artist*

Michael Dillon. Headboard. Forged iron. 6' h x 6' w x 4" d. Forged from 3/4" square iron, this piece has no welds. It is entirely built using mortise and tenon and rivets for its construction.

Shawn Lovell. *Tree Bed.* 2007. Forged and fabricated steel. Queen size 7.5' h, 7' w, 8' l. Leaves and berries are forged out of .5 square bar and then scarfed and forge welded to form the upper branches. The trunks are fabricated from steel pipe that has been packed with sand and then forged, textured, and shaped. The sand allows the pipe to be forged as if it were solid. If I were to try to hit it hot with a hammer without doing this, it would dent the pipe rather than form the natural, subtle shape I am after. After shaping, the pipes are welded together and forged details are added, knots, branch stubs, sears, and so on. *Photo, Anita Bowen*

All the Rest

Forging Ahead Inc. is a family operated business. Rod Pickett does all the design and layout work. Rod and his sons, Lee and Thom, forge and fabricate both ferrous and non-ferrous metals. Rod's wife, Julie, manages the office. Here is an example of their work.

Rod Pickett, Forging Ahead Inc., Durango, Colorado. Forged steel and bronze powder room vanity. The posts were forged from 2" steel and sit on top of forged balls. The steel vanity base was assembled using steel rivets. The countertop and backsplash were formed from bronze, polished and then sealed. The granite bowl was provided by others. Private residence. Design by Catherine Frank of Studio Frank, Telluride, Colorado, and Rod Pickett, Forging Ahead Inc., Durango, Colorado. *Photo, Julie Pickett*

Rik Mettes and Brenda Bales at Wyoming Metalsmiths. *Whiskey Creek Hall Tree.* Aluminum, glass, iron, copper, stone, and cedar slabs. They state, "This hall tree was kind of a time eater though. We did it for a Western/Rustic show. It is now in a private collection. The W. C. Hall Tree is a kind of an art deco/ lodge/ art nouveau medley that we designed. I don't think it fit in too well with the other pieces in that show, but it was a fun project. It got its name from the stone floor in the bottom of the storage area that was from Whiskey Creek, Montana."

Lisa Elias. Music Stand. 2007. Mild steel. The nob on the side moves. 60" h x 22" w.

Greg Price. Music Stand. Mild steel, scrolls on ledger 5/16 x 1/2" forged by hand without use of jig, decorative nuts and bolts chiseled and chased, ledger is traditionally joined with collars and rivets and is fully adjustable, base scrolls forged from 1/4" x 1-1/2", upright is 3/4" round with pipe sleeve for vertical adjustment. Overall dimensions: 19-1/2" w x 65" h; ledger dimensions: 17" h x 19-1/2" w. Forged in coal forge, hand sanded with hand rubbed oil wax finish. Private residence. *Photos, artist*

John Little. Music Stand. Forged steel. 44" x 18" x 18". Breaks down into three pieces for easy transportation.
Photo, John Little

172

Rod and Lee Pickett of Forging Ahead Inc, Durango, Colorado. Copper Range Hood. Deeply embossed texture on a copper and steel range hood. Offset lap joints with rivets join the forged steel straps. Rod used repousse to raise the rose out of the copper. The careful use of heat and acid patinas achieved the rich color before sealing the entire hood with wax. *Photo, Julie Pickett*

W.R. Nagor. Kitchen Hood, 2003. Forged copper and iron. All riveted construction. Homestead, Florida.

Chapter 7
Outfitting a Fireplace

For as long as there have been fireplaces, there has been need for specific equipment to stoke the fire and keep the burning embers from setting fires where fires are not wanted. While there is little need for all the cooking accoutrements found in the fireplaces in Colonial homes that once kept blacksmiths busy, fireplace screens and tool sets are still required. However, today's best fireplace screens combine artistry with functionality, complementing the room and the home in which they are found. Today's artist blacksmiths have taken these useful objects to new heights of creativity, height never imagined by those Colonial blacksmiths of old.

Greg Price. White Oak Fire Screen. Mild steel. 36" h x 52" w. Hand hammered texture on frame and doors, tooling made by artist for bark texture on branches, dies made by artist for acorns, five different leaf shapes and sizes plasma cut out of 16 ga. sheet metal then hand textured and veined in a coal forge, hand sanded with hand rubbed paste wax finish, private residence. *Photos, John Bechtold Studio*

175

176

177

George Witzke. Grape Vine Fire Screen. 2007. Mild steel. 32" h x 36" w. Witzke Iron Works had previously created a pair of custom refrigerator pulls in a grape vine theme for this Tempe, Arizona, client prior to this commission. The client took pictures of his pulls and used the photos in a CAD program to design this fire screen and matching fire tools. *Photo, April Witzke*

Shawn Lovell. Fireplace Screen. 2003. Forged steel. 29" x 27". Private residence, Alamo, California.

John Rais Studios. *Pondscape* Fire Screen. 2002. Forged steel, bronze, patina. 29" x 40" x 9". This, like many of my fire screens, has a removable framed screen. A decorative bronze panel is installed for the seasons when the fire screen is not used. The bronze panel has a wetlands painting created entirely from patinas.

Bill Howard. Fire Screen. Iron. It took approximately 500,000 hammer blows to execute the repousse and the forged frame.

Michael Wolfe. Fireplace Screen.

Michael Wolfe. Fireplace Screen.

181

Tony Higdon. Vine Fire Screen. 2006. Hand forged steel. 38" x 38". Private Residence. *Photos, artist*

Greg Eng. Fireplace Screen. Steel, acid wash and oiled finish. Constructed to fit the opening of a 59" x 51" fireplace. Forged steel, textured frame out of 3/8" x 1-1/2", rivets 7/16" d, 3/4" x 11-1/2" hinges with 2-3/4" tall bronze finials. All work designed and made by Greg Eng.
Photos, Brenda Eng

Maria Cristalli. Cedar Screen. 2006. Wrought iron forged and etched in muriatic acid to look like bark. The inspiration comes from trunks of huge cedar trees that are part of their view.

Jim Pepperl, of Pepperl Forge, Silver City, New Mexico, created the following fire screen and tools.

Jim Pepperl. Fireplace Screen and Tools. 2005. Forged steel and wire cloth. Small external barrel hinges with internal mounts and heat resistant magnetic catches keep the design very simple and contained for this Santa Fe residence. 26" x 27" x 27".

Phillip Bowling. Single Panel Fire Screen. Steel with hand rubbed oil finish. Hand forged and hammered to replicate the mantel design. Private residence, Malibu, California.

Phillip Bowling. Hand Forged Single Panel Fire Screen. Steel with hand rubbed oil finish. Private residence, Calabasas, California.

Phillip Bowling, of Noble Forge, has this to say about his art, "As artist blacksmith and founder of Noble Forge, I have been preserving the time-honored tradition of hand-forged metal artwork for over a decade in Southern California. I began my artistic journey in 1990 in Kentucky. It is there that I served as an apprentice in the Boilermaker's Union. Individuals who had forged hand-made tools for generations were the powerful influences behind my introduction to the ancient art of blacksmithing.

In 1996, I journeyed to the West and founded Noble Forge. With great satisfaction, I found a true sense of myself and my calling, to uphold the ancient craft of hand-forged metal artwork. My uncompromising commitment for maintaining the purest form of my craft is evident in each one of my uniquely beautiful pieces."

Phillip Bowling. Hand Forged Fire Place Doors. Steel and copper with patina finish. Private residence, Brentwood, California.

187

Neil Mansfield. *Shooting for the Stars* Andirons. Forged and fabricated black iron. 30" w x 12" h x 24" d.

Neil Mansfield. Forged and TIG-Welded Fireplace Tool Set. Bronze, iron, copper rivets. 36" h x 12" w.

Artist blacksmith Jeff Mosher creates his artwork in his shop in Easton, New York. While Jeff has been working with steel since his early teens, he began really focusing on blacksmithing in his late thirties, about ten years ago. He states, "I was introduced to a fellow who was into blacksmithing and he showed me the things he had made and all the really cool equipment and tools he had about. I am glad he lives just doen the road a piece! We did some wheeling and dealing and I ended up with a drop hammer and a 25# little giant. He is the one who got the spark into me to forge ahead in this field." Here are examples of his work.

Jeff Mosher. Andirons. Hand wrought and forged mild steel and brass. Twisted 2 1/8" mild steel. 2 1/8" and 2 1/2" glass balls. Adirondacks cabin location.

Jeff Mosher. Fireplace Tool Set. Forged and riveted mild steel, twisted and split. 35" h x 18" w.

George Parker. *Phoenix* Andirons. Designed for a double-sided fireplace. 48" w x 18" h x 24" d. *Photo, Ansen Seale*

Tessa Wittman. Andirons. Mild steel. 23" x 18" x 16". The original design of thes andirons was much more complicated than the final product. As I forged 18th scale prototypes I dropped a number of design elements and produced a much more elegant piece as a result of simplifying. *Photo, Mary Vogel*

John Phillips, of Phillips Ironworks in Montgomery, Alabama, states, "My admiration of the renowned craftsmen who could transform cold, rigid steel into warm, flowing architectural pieces prompted my start in artist blacksmithing.

Combining the personal and fluid nature of hand hammered iron with contemporary methods and elements, I strive to create one-of-a-kind and limited edition architectural elements that preserve the mystical properties of the metal, while exploring more cutting edge designs."

John Phillips. *African Andirons.* Forged steel. 26" h x 26" w x 18" d. *Photo, John Phillips*

John Phillips. *Primitive Andirons.* Forged steel. 24" h x 28" w. *Photo, Mark Vaughn*

John Phillips. Primitive Fire Tools. Forged steel. 36" h x 16" w.
Photo, Mark Vaughn

Lisa Elias. Fireplace Tools and Wall Mounted Rack. 2007. Mild steel. 30" l tools.

Michael Wolfe. Fire Tools. *Photo, Stanly Livingston, Ann Arbor, Michigan*

Michael Wolfe. Fire Tools and Stand. *Photo, Stanly Livingston, Ann Arbor, Michigan*

Jim Pepperl. Fire Tools and Stand. 2004. Forged steel. 28" x 11".

Chapter 8
Lighting Fixtures & Candle Holders

Presented in this chapter are lighting devices of all kinds from simple, yet elegant candleholders and wall sconces to imaginative desk lamps and elaborate chandeliers. Prior to the development of the electric light, one sign of a person's wealth and status was the ability to light an entire house with candles in the evening. This was an expense most people simply could not afford. Benjamin Franklin actually came up with daylight savings time as a scheme to reduce the use of candles in the evenings, sparing that particular expense.

The first iron candlesticks date back to the fourteenth century. Early examples were very basic affairs. By the seventeenth century, techniques and technologies had developed to the point where more delicate, intricate work was possible on candlesticks. Most of these candlesticks were destined for the homes of the middle class and peasants, neither of whom would leave candles burning in every room in the night. (Baur 1996, 12)

James DeMatis. Wrought Iron Chandelier. 2007. Hand forged iron. I was given complete artistic license regarding the design of this commissioned work. 40" d.

George Parker and Randy Kiser. Chandelier. Designed for an event hall in the Museum of South Texas History. Details include longhorn cattle, horses, and hummingbirds. 8' 8" w x 10' h. We only had three criteria to follow when designing this piece: 1. It could not weigh more than 5000 lbs; 2. It could not be greater than 10' in diameter; 3. It had to relate to life in the Rio Grand Valley. These are probably the loosest guidelines I have ever had to follow! *Photo, German Garcia*

199

Since he started forging steel and working wood in the early 1970s, Thomas Latané has been most interested in traditional hand working techniques and historic design vocabularies.

The small scale of most of his work makes a power hammer unnecessary. Tom keeps a couple sledgehammers in the shop for use by occasional apprentices in forging heavier elements and tooling. All welding is done using the charcoal fired forge.

While most of the metal forming is done with the hammer at the anvil, Tom has made open and closed dies to fit the hardie hole for shaping hot steel. Tom employs many chisels and chasing tools, the hot metal often being supported by a wet wood block to avoid distorting the reverse side.

After forging, Tom's work is refined by cold chiseling, chasing, and/or filing, then assembled with mortise and tenon or riveted joints. Most projects involve as much cold work as hot forging.

Tom Latané. Seven Light Chandelier. 2006. Forged mild steel components were forge welded tenoned or riveted together. Finish is beeswax and linseed oil mixed with iron oxide. 15" w and 24" from bottom to ornament on rod. The candles, distributed throughout the piece, illuminate the arches and structure above and cast interesting shadows. *Photo, T & C Latané*

Artist blacksmith Bill Robertson describes his work, "I am a fifty-year-old artist blacksmith working with my wife, Patty Draper, out of our shop, Applecross Forge, in Tallahassee, Florida. I was introduced to forging iron in 1989 and it quickly turned into a passion. I am active on the board of directors of the Florida Artist Blacksmith Association, having served as the Newsletter Editor, Vice President, and currently as President. In addition to forging metal in my own shop, I enjoy demonstrating at blacksmith events and teaching at schools like the John C. Campbell Folk School. My hobby in iron was starting to interfere with my work, so three years ago I closed my taxidermy studio after twenty years to pursue iron work full time. My wife Patty developed an interest in blacksmithing a few years after me and has now retired from her law career and works out in the shop with me. I like to create unique lighting and I'm always getting sidetracked trying to learn new techniques and incorporate other media into the projects."

Bill Robertson. Chandelier. Forged from mild steel. 20" x 20".
Photo, George Dawson

Bill Robertson. Bobcat Chandelier. Forged from mild steel with bobcat skulls that were left over from closed mouth mounts from my taxidermy business. 20" x 27". *Photo, George Dawson*

Lisa Elias. Hanging Candelabra. 2007.
Mild steel. 48" w x 30" l.

John Medwedeff. *Solomon Chandelier*. 2000. Forged and fabricated steel, mica. Residence, Knoxville, Tennessee. 54" d.
Photo, Jeff Bruce

Maria Cristalli. Dining Table Light. 2006. Textured bar and riveted construction.

203

Rachel Miller. *Branches Candelabra.* Hand forged steel. The buds on the branches candelabra are forged from square pipe and represent the buds that appear on trees during the first days of spring. 21" h x 18" w x 12" d.

Tony Higdon. Two Candelabras. 2003. Hand forged steel. Episcopal Church Sanctuary, Danville, Kentucky. 22" w x 5' 6" h. *Photo, Greer Photography*

Dan Nauman. *Pascal Candlestick*. 2007. Forged and waxed mild steel. Note that the candlestick's top may be removed, and used for processional purposes. 52" h x 21" d.

205

Dietrict Hoecht. Orchid Cactus Candleholder. We have an orchid cactus hanging pot. It has the most intriguing shapes of long, veined leaves, with extended and narrowed sides. These leaves hang down and bend and twist all together. I scratched my head over this wonderful work of nature and decided on duplicating it by flattening out an angle iron and alternately thinning its sides. A bit of curling and bending of the resulting leaf produced the candleholder.

Jeffrey L. Wallin. *Droplet Candlestick.* Mild steel. *Photo, Keith Cotton/Keith Cotton Photography*

Roberta Elliott. *Off the Wall* Sconce. 15" x 12" x 9". *Photo, Larry Sanders*

Todd Campbell. Lamp. 2005. Forged steel lamp based with custom hand blown glass by Fire Island Glass. Private residence. 48" x 12" x 12".

207

Erika Strecker. Floor Lamp. 2006. Hand-forged steel and hand blown glass. *Photo, M. Resny Photography*

Erika Strecker. Floor Lamp. 2005. Hand-forged steel and hand blown glass. Private residence. *Photo, M. Resny Photography*

Michael Glennon speaks about his experience and art, "I am an artist blacksmith from central Illinois. I discovered blacksmithing quite accidentally through another interest, traditional woodworking. Unable to find many of the woodworking tools I needed, I began to experiment with some basic forging techniques in order to reproduce them.

Soon I was dedicating more time toward blacksmithing than I was toward woodworking. Thus began a devotion to the art as well as the artistry of hammering hot metal into beautiful forms. In woodworking, material is either added or taken away to achieve a particular result. A blacksmith on the other hand, inherently transforms material from one form into another. The metal is moved and shaped, much like clay. The hammer marks left on the completed work represent moments that have been captured in time.

Since those early days I have committed myself toward further developing my metalsmithing techniques, as well as nurturing my love for the art. For the past five years I have volunteered as a demonstrator of late nineteenth century blacksmithing technique at Midway Village Museum Center in Rockford, Illinois. I perform several other demonstrations throughout Illinois each year. I have been involved in a couple of exciting restoration projects, one involving the reproduction of antique barn hardware. I recently have begun doing larger commissioned works, such as custom gates, architectural elements, and lamps."

Mike Glennon. Arts & Crafts Lamp. 2006. Forged steel, copper, and glass. Donation to Midway Village Museum Center 2006 Fundraising Gala; 120 year old facets of glass were chosen to compliment the Victorian theme of the event. 30" h.

Jed Krieger. Table Lamp. Forged mild steel with raised copper panels. 14" x 14" x 11" h.

John Little. Adjustable Desk Lamp. Forged and fabricated steel. The retaining ring on the base holds the forged ball against a small, strong spring in a hole in the socket. The pressure of the spring holds the lamp in any orientation. 18" x 20" x 6". *Photo, John Little*

Bill Robertson. *Lamp with Rocks.* Forged and textured mild steel. The shade is made from leather with river rock feet. 17" x 17".

Bill Robertson. *Vine Lantern.* Chiseled mild steel plate and textured round stock with red fused glass panes. It has a stove polish finish. 30" x 5". The ceiling roots span 20" x 20". *Photo, George Dawson*

David Thompson. *Frozen Motion Lamp.* Forged steel, glass, and crystal. 18" w x 77" h.

David Thompson. Lamp Post. Forged steel and bronze. 9' h x 17" w.

John Phillips. Lantern Stand. 2003. Forged steel and a Bevelo lantern with custom copper crown. 10' h. This lantern stand is one of a pair I built for an estate in Birmingham, Alabama. They each took more than 300 hours to complete.

One interesting feature of the stands is the progression of stock sizes and textures from the vertical edge to the center. The steel progresses from square to flat to round and the texture on this piece becomes more refined in an attempt to give the stand more visual depth. The feet are forged from 1" x 2 1/2" flat bar.

One of the biggest challenges on this project was to get the scale correct. I designed the stands around the existing lanterns and then scaled them into pictures of the house with Adobe Photoshop™. Once we had a good idea of the size, I made plywood mock-ups of the stands and stood them up with the lanterns balanced on top to make sure that we were on track. The computer simulation made the design process go much smoother and was very reassuring to the client.

John Boyd Smith. Wall Sconces – Savannah, Georgia. These Gothic-style sconces are eight-feet tall, and weigh one ton each. They are the largest wall lamps ever forged in the history of Savannah, Georgia. They have been featured on CNN television in an international broadcast.

Chapter 9
Decorate Doors Dynamically

Here we cross the threshold into a world of unique and unusual door hardware. As individuals seek to make their homes unique, they wish to add exceptional hardware to their custom-made doors. Here the world of the locksmith meets the creativity of the artist. As Dona Meilach noted in 2006, this is a growing field for artist blacksmiths.

We begin with Tom Latané, who shows us some of what is possible.

Tom Latané. Small Display Door. 2004. Forged steel hardware. This door is a single salvaged board of American Chestnut. The forged steel hardware was inspired by Medieval Norwegian church doors. Tom made the small display door for himself because he was so taken by the photos he had been studying of Norwegian hardware when he prepared a bid for doors on a Lutheran Church. He has been making similar, larger scale hardware, one piece a year, for a door at the Vesterheim Museum in Decorah, Iowa. 22 1/2" x 4" x 39" (with frame). *Photo, T & C Latané*

Greg Eng. Decorative Door Handle. Designed and made by Greg Eng. *Photo, Brenda Eng*

Michael Wolfe. Door Pull, Back Plate, and Key Cover. Copper plated.

Steve Hackbarth. Door Handles. Steel. Made for St. Mary's Oratory in Wausau, Wisconsin. 10" h. *Photo, artist*

Steve Hackbarth. Door Knocker. Steel. Made for St. Mary's Oratory in Wausau, Wisconsin. 12" d.

218

John Phillips. Double Eagle Knocker. 2003. Forged steel and mounted on wood salvaged from an old barn in Pike County. The red color is original to the barn and the blue and white were painted to match. The double eagle heads represent our nation's strength and vision. The knocker is 17" h and 18" w and the entire piece is 26 3/4" h and 19 1/4" w.

Jim Pepperl. *Timberline Latch.* 2004. Forged steel. This hardware was inspired by a photograph of a latch from the Timberline Lodge on Mount Hood in Oregon. The offset assembly of the push/pull scroll allows both interior and exterior to have the same hand grasp as opposed to the standard small pointed interior lift of most bar latch designs. 4" x 5" x 3 3/4".

Jim Pepperl. *Cartoon Hardware I & II.* 1998. Forged steel, enamel paint, and commercial hardware. Designed by an artist friend, Keith Kleespies, who is always entertained by the resolutions I make in translating his two dimensional drawings. These are part of an ongoing series. 13" x 6" x 2 1/2".

Chapter 10
Still There Is More

The creativity of the artist blacksmith knows no bounds. Back in the day, blacksmithing divided into several specialty areas, including locksmiths, gunsmiths, bladesmiths, armourers, and ferriers. Today's artist blacksmiths continue to specialize and diversify. Here are examples of the works of today's bladesmiths, jewelers, and the creators of boxes, signs, utensils, and more.

John Lewis Jensen focuses his talents on knives. Here is his statement about his work, "Knives are my primary form of expression and exploration, and therefore encompass most of my day-to-day artistic creation. Knives as art, offer me a focal point for many of my varied interest.

The knife is an art form unlike any other, both rich in form and function. It is aesthetic, and quite obvious in its direct use. This poses an interesting challenge; to create art out of an object that is so defined by its form and associations is an interesting and complex task. My work is about the exercise of pushing boundaries within a certain set parameter.

In these modern times 'Art' is defined as a platform for ideas. The knife is where I exercise and expresses my thoughts on art, culture, sociology, archeology, anthropology, and metaphor. One of the many objectives of art is to challenge people's views. From a psychological standpoint, knives evoke strong emotions. Personally, the art-knife represents the ideology of dualism; the art-knife holds beauty and violence at the same time; two concepts at opposite ends of the spectrum are represented in one object."

John Lewis Jensen. *Riptide*. 2000. The blade is a Nickel Mosaic / Checkerboard – Flower Worm Hole Damascus, with swedge and bevel. Hollow ground on an 8" wheel. 13 1/16" open, 7 1/2" closed. *From the Collection of Gerald Hopkin, Barbados*

John Lewis Jensen. *Strata Dragon.* 2004. The blade is a "Modified Ladder" pattern Damascus steel, with swedge. Hot Blued, selectively polished, with masked Flame pattern on the ricasso. 15 1/2". *From the collection of Dr. David Darom, Israel*

John Lewis Jensen. *Synaptic Surge.* 2005. The blade is accordioned Mosaic Damascus steel, with composite "Explosion" pattern Damascus steel cutting edge. Deep etched and chemically colored, with milled accents. Hollow ground on a 5" wheel. 8 1/2".

Robert A. Rupert. Japanese Style Knife. Etched carbon steel with copper fittings.

Robert A. Rupert. *Fruits of the Earth* Sign Bracket Installation. *Photos, Bob Rupert*

225

Neil Mansfield. Blacksmith's Company Name Forged Sign. Wood mount on display. 24" l x 20" h.

John Phillips. Blount Cultural Park Sign. 2002. Forged and fabricated steel with teak wood posts. 26' h x 17' w.

Mike Edelman. Wearable Sculpture. Brass and copper. 4" x 3". *Photo, artist*

Mike Edelman. Wearable sculpture. Brass and copper. 5" x 3". *Photo, artist*

Mike Edelman. Wearable sculpture. Brass and copper. 4" x 2". *Photo, artist*

David E. Anderson has been a jeweler for over fifty years. He also enjoys blacksmithing and in this piece he has combined the techniques of both to great effect.

David Anderson. Iron and Jasper Pendant. Designed for casual wear on a leather or nylon cord. Originally made as a raffle prize for the New York State Designer Blacksmiths Christmas dinner, but has become one of the most popular items in David's jewelry store. David states, "The iron in this piece is welded using the Smith Little Torch. It is great for joining small pieces of iron." 2 3/4" x 1 1/4".

Tessa Wittman. Damascus Cuff. Damascus steel.
2 1/2" x 3" x 1 1/2". *Photo, Mary Vogel*

Tessa Wittman. Calipers. Damascus steel.
14" x 8" *Photo, Mary Vogel*

Elmer Roush. Sixteenth Century European Padlock.

230

Bill Robertson. *Rooster Lock.* The key is forged from a single piece of stock. The roosters were copied from some found on a 16th century Italian gate. They were cold chased from 18 gauge 1010 draw quality steel over pitch. The lock was patterned from one found on a dirt road to our house where a plantation house stood in the 1800s. The lock pieces were found over a period of two years following heavy rains. The rooster plate and the fleur-de-lis on the back were added for effect. The lock measures 3" x 4" x 3/4".

Bill Robertson. Lock. Forged from mild steel. The top plate was cut out with a jewelers saw. All the parts of the lock are riveted together. The key is forged from a single piece of steel. The lock size is 3 1/2" x 2 1/2" x 5/8".

Darrell Markewitz. *Celtic Hand Mirror*. 2001. Forged mild steel with brass rivets and commercial mirror. This is one of a series of small of hand mirrors. It was created as a donation to a fund raising silent auction for the "Earth, Air Celtic Festival" in Goderich, Ontario. The design springs from the hilts of a number of Celtic Iron Age swords, where a human figure cast in bronze forms the handle.

Jeff Benson. *Leaning Cedar Mirror.* Forged mild steel and mirror. Frame is hammered mild steel with antique pewter finish. Frame ends near cedar tree to give the impression of nature breaking through. 26" w x 36" h. *Photo courtesy of Jane Benson*

Jeff Benson. *Windswept Mirror.* Forged mild steel and mirror. Hand forged decorative mirror projects an image of organic sophistication. 18" d. *Photo courtesy of Ryan Commercial Photography*

John Rais Studios. Bronze Mirror. Forged bronze, patina. 31" x 19" x 5".

Rebekah Frank. *Raphide—Calcium Oxalate Series #1.* Forged Steel lined with Copper, finished with oil. This is the first in a series of sculptures depicting the calcium oxalate crystals that occur as a natural defense mechanism in plants. A raphide is a needle shaped crystal found by the hundreds within the cells of young leaves. The crystals naturally bundle together and serve to deter browsing. This particular crystal shape is found in the grape vine. I found the shape a pleasing form and well suited to a box, where the shape of the crystal continues with it's natural function of protection. I enjoy using a mixture of materials to give a variety of colors and textures to the pieces I create. In this piece, the individual forged pieces give a sense of age and the facets reflect light. The opening of the lid reveals a polished copper interior of a salmon color that is a surprise considering the simple austerity of the outside. 6" d x 18" l. *Photo, www.onioncreekstudio.com*

Tom Latané. Oak Chest with Hasp Lock. 2007. Rived red oak. Designed to the specifications of a customer who wanted the chest as a 25th wedding anniversary gift. Forged steel hardware has been pickled in vinegar and sanded. Dovetailed chest walls taper towards the lid. The lid, carved in one piece is hollowed out underneath. The key for the spring loaded hasp lock has the number twenty-five in Roman numerals in silver in the bow and is fitted with a loop to be worn on a chain. The oak has been darkened with iron dissolved in vinegar. Wood and hardware were finished with beeswax and linseed oil. 7" w x 7" h x 10" l. *Photos, T & C Latané*

Tom Latané. Oak Chest with Padlock. 2006. Salvaged black oak boards hand planed to remove weathered surface. The hasp and hinges were forged. The other iron bindings were cold chiseled from rusty steel sheet. All nails were hand forged. The oak was treated with iron-laden vinegar, (spent pickle used to remove iron oxide from forged pieces prior to filing,) which stains the wood. The wood and hardware were coated with beeswax and linseed oil. The lion face padlock was made earlier and was Tom's first padlock. 11 1/4" x 9 3/4" x 14 3/4". *Photos, T & C Latané*

Tom Latané. Cherry Box. 2006. Black cherry quarter sawn by hand and carved before assembly. This box was inspired by small 15th century German caskets. Simple hasp lock has spring-loaded bolt. 6" x 4" x 8 1/2". *Photo, T & C Latané*

John W. Gehl. *Unbreakable Bowl.* Formed of heavily pitted steel plate; the base is incised and embossed. Flame colored, finished with linseed oil and bee's wax. 10" d.

Steve Hackbarth. Censer and Incense Boat. Steel. This censer was made for the Lady of the Valley Cistercian monastery in Sauk City, Wisconsin. The Fleur de Lis motif was chosen due to the fact that it is the symbol of the Virgin Mary. 4 1/2" d. *Photos, artist*

Wayne Henderson. *Growing Around.* 2007. Mild steel, paste wax over "elephant skin" scale. I make a lot of small and medium size bowls that often are designed around nature themes. The vine that undulates around the shallow depression in this bowl reminds me of the many vines growing on the rock outcropping around my house, vines that twist around limbs and squeeze through the cracks in rocks. When the spring rains fill the shallow indentations of a rock, there is always a creeping vine soon to follow, seeking the moisture of life. And, of course, over time more leaves, branches, roots, and vines grow from that one. Eventually they all dig into the stone to help form more shallows where water will collect and encourage more vines to grow. It is a never-ending circle of life that I love and try to capture in my ironwork. 7.5" d x 1.5" h.

243

Jim Pepperl. *Not Harvey.* 2001. Forged steel and bronze. Design by Mary Elizabeth Jane Colter (circa 1930), as ashtrays for several of the Santa Fe Railway's hotels. 47" x 11" x 16".

Scott Sweebe. Yard Bell. 1997. Narrow gauge railroad track, welding tank, 6" x 6" x 1/4" square steel tubing, automotive coil spring. All of the metal is recycled material found at a salvage yard. A decorative yard bell sculpture using punched holes and mortise and tenon joints pegged joints. 18" x 33" x 7". *Private collection, Flagstaff, Arizona.*

Tony Higdon. Copper and Steel Mailbox. 2006. Hand forged steel, copper, and stone. Private residence. 4' h x 50' x 3' w. *Photo, artist*

Frank Jackson. Porch Supports. *Photo, Tim Fleming*

Jeff Mosher. Wood Elevator. All hand wrought mild steel, inlaid brass, riveted and collared. Adirondacks Cabin. {above and opposite page}

Bill Howard. Neo-Georgian Canopy. Iron frame and copper roof with 1/2" tempered glass side screens. The lamps were brass and oven slumped plexiglass. The scroll work was hand forged from 3" x 3/4" iron bar with each set weighing approx 200 lbs. The largest hand forged scrolls in this country that we know of. There were 2 sets for each of 3 entrances for a total of 1200 lbs. The whole installation required 8000 lbs iron, 50 lbs brass, 2000 lbs glass and 1800 lbs copper. 3520 Lakeshore Drive Condo Association. There was a 35 foot portico, 2 canopies as shown and a large iron gate.

Maria Cristalli. Well Cover. 2001. Forged pure iron with a wax and oil finish.

Teresa Jenkins. Weathervane.

Mike Sohikian. *Direction of the Sun and Moon*. Working Windvane. Steel, aluminum, and concrete. Exhibited at the Toledo Museum of Art. 0.78" x 90" x 36".

Mike Glennon. *Clock Study.* 2007. Forged steel, copper. This is my most recent work. Inspired by artist blacksmith Otto Schmirler, it is a study for a future project, which will include hand wrought clockworks. Having recently moved from Rockford to Normal, Illinois, I have yet to set up a new shop. Much of the work on this piece was done at Illinois Valley Blacksmith Association (IVBA) open forge events or anywhere else I could find a smithy to work in, including my own portable forge set up outside in the snow. The individual pieces of this clock have spent time on half a dozen anvils of various personalities. 22" d.

Lee Badger. *Dragon Bell Striker.* Photo, Frank Herrera. *Dragon Bell Striker* Installation View. *Photo Courtesy of Durward Center.* Bell Striker Dragon was a project related to an historic clock. In this case, the clock was being installed in a brick row house, and the owner requested an imaginative bell support and striker for the building's exterior. The dragon was conceived by engineer, designer, and artist blacksmith Paul West. The dragon's eight-foot wingspan and six-foot body length provide support for the vintage 110 lb. cast bronze bell. The dragon's tail is the bell striker. A Seth Thomas #16A tower clock movement inside the building pulls a striking cable that runs through the wall into the dragon's body and tail.
Badger and West created the dragon in Badger's shop and installed it under the direction of clock specialist Durward Center. To create the wings, hot-hammered steel sheet was welded to forged ribs. Individually shaped scales cover a structural armature that forms the dragon's body. The belly scales were made from sections of 11 gauge copper plate. The dragon's head also conceals structural framing with sheet steel and forged facial features and 2" ball bearings for eyes.

Lee Badger. Gothic Revival Clock Tower. *Photo, Sutter Photography*

This Gothic Revival clock tower displays an historic clock that served for many years in the steeple of St. Michael's Church in Rochester, New York. Fully operational and historically correct in its new home, the clockworks rest on an elegantly painted cast iron chassis in the base of the tower. A brass drive shaft operates the original clock faces above. Clock enthusiasts recognize it as an E. Howard Company #2 Tower Clock with three separate weight-driven trains for timekeeping, for hour striking and for Westminster chimes at the quarter hours. The five bronze bells behind the dials were cast by Taylor in London.

The design concept for the new steel and cast iron tower was a collaboration between architect/designer Lee Pharr, clock restoration specialist Durward Center and the owner of the clock. Lee Badger was commissioned to bring the design into reality at Anvil Works studio in Hedgesville, West Virginia. Constructing the tower was more than a fabrication project. It was an exercise in creative collaboration, construction coordination and metal working versatility. Badger was regularly in touch with the design collaborators to assure that the tower met its functional and aesthetic requirements. The clock specialist provided a full-scale maquette of the clock works to work out mechanical details and came to oversee the critical placement of pulleys and bearing supports. Badger and the architect/designer conferred often to adjust and adapt structural and ornamental details.

The greatest challenges during construction were in managing a myriad of details and in combining a diversity of ironworking processes. The Gothic Revival design required hand forged pieces to coordinate with ornamental castings and structural steel. Many different castings needed to be divided, re-combined and assembled to fit the tower's proportions and dimensions. Badger used a wide variety of different cutting, bending, forming, welding and joining techniques to achieve the necessary combinations. Steel tube, sheets and plates formed the structure. The tower was constructed in two sections for transportation to the owner's site. Overhead conditions in the interior space required a delicate dance between two forklifts to place the upper section onto the lower legs and base. The tower project took eight working months to complete. The clock specialist and the clock's owner spent several more months perfecting the operational installation of the clock and detailing the tower with gilding and a polished hardwood floor.

Lee Badger. Victorian Clock Tower. *Photos by Todd Herbst, Sutter Photographers*
The Victorian Clock Tower followed the Gothic Revival Clock Tower's example. Fourteen feet taller and three times more massive, it was designed to display another historic tower clock, a giant Howard #3 in the collection of the Sanfilippo Foundation in Barrington Hills, Illinois. Like its predecessor, Lee Pharr developed the tower's complex design and Badger created it in his shop. The tower combines more than 11 tons of hand forged elements, castings, stampings, ornamental and structural steel. Decorative pressed steel sheet used in the tower's capitals and cornices came from the W.F. Norman Company's 1909 "Hi-Art" catalog still available today. Six other specialty services and suppliers provided parts and pieces for the project. The tower was assembled in eight sections including three upper frames, four column assemblies and the base. Badger hired a local rigging company to move the pieces around his shop and stack completed sections outdoors. The growing structure outside the Anvil Works shop drew press attention and the wonderment of casual passers-by.

After ten months in construction and final assembly in a Sanfilippo showroom, mechanical restoration experts on the Foundation staff installed the historic clock. Operational fittings and adjustments took another year, along with the elaborate painted and gilded finish. Equally ornate and unusual mechanical antiques surround the tower in its permanent setting including a European salon carousel, fairground and dance hall organs, several steam engines, and a locomotive.

253

Bibliography

Allen, David G. "A Little Bit of Blacksmithing History." Appalachian Blacksmiths Association, 2008. http://www.appaltreenet/aba/education/historical/history3.htm.

Baur, Veronika. *Metal Candlesticks: History, Styles, and Techniques.* Atglen, Pennsylvania: Schiffer Books, 1996.

Chicora Foundation, Inc. Cemetery Ironwork, 2008. http://chicora.org/cemetery_fences.htm.

"Glossary." Appalachian Blacksmiths Association, 2008. http://www.appaltreenet/aba/terms.htm

Jernberg, John. *Forging.* Chicago: American Technical Society, 1919. *Courtesy of Google Book Search*.

Meilach, Dona Z. *Ironwork Today: Inside & Out.* Atglen, Pennsylvania: Schiffer Publishing, 2006.

"Ornamental Ironwork." *The Columbia Encyclopedia*, Sixth Edition, 2007. http://www.encyclopedia.com/doc/1E1-iron.html

Resources

No book of this sort is ever produced alone. Here is a listing of organizations that were helpful in pulling this project together. This may not be complete and if not, I apologize. I truly appreciate the help everyone provided.

Artist Blacksmith's Association of North America, ABANA
Alex Bealer Blacksmith Association
Appalachian Blacksmith Association
Artist-Blacksmith Guild of South Carolina
Blacksmith Association of Missouri
Blacksmith Organization of Arkansas
Bonneville Forge Council
California Blacksmith's Association Calsmith.org
Capital District Blacksmiths
Central Virginia Blacksmith Guild
Connecticut Blacksmith Guild
Florida Artist Blacksmith Association
Four States Iron Munchers
Great Plains Blacksmith Association
Guild of Metalsmiths [MN], Metalsmith.org
Gulf Coast Blacksmiths Association
Illinois Valley Blacksmith Association
Indiana Blacksmithing Association
Kentucky Blacksmiths' Association
Louisiana Metalsmiths Association
Michigan Artist-Blacksmiths Association
Mid-Ohio Blacksmiths (MOB)
Mississippi Forge Council
New Jersey Blacksmith Association
North Carolina Chapter of ABANA
North Texas Blacksmiths Association
Northeast Blacksmiths Association
Northwest Blacksmiths Association
Northwest Ohio Blacksmith Association
Ocmulgee Blacksmith Guild
Old Dominion Blacksmithing Association
Ontario Blacksmiths
New England Blacksmiths
Pennsylvania Artist Blacksmith Association
Pittsburgh Area Artists-Blacksmiths
Prairie Blacksmiths Association
Snagmetalsmith.org
Southern Blacksmith Association [GA]
Southern Ohio Forge and Anvil
Southwest Artist-Blacksmiths Assoc. [NM]
Texas Artist Blacksmiths Association
The Forge
Tidewater Blacksmith's Guild [VA]
Upper Midwest Blacksmiths Assoc. [WI]
Western Reserve Artist Blacksmith Assoc. [Ohio] WRABA

Here is a listing of the contributing artist blacksmiths found in this book.

Anderson, David E.: Erik Jewelers
Tonawanda, New York

Badger, Lee: Anvil Works
Hedgesville, West Virginia

Beck, Nicole
Illinois

Benson, Jeff: Benson Designs LLC
Green Bay, Wisconsin

Billings, Rudy L.: Red Hot Iron Works
Austin, Texas

Bowling, Phillip: Noble Forge
Valencia, California

Brown, Bill: Anvil Arts Studio, Inc.
Linville Falls, North Carolina

Bujold, Anne
Portland, Oregon

Campbell, M. Craig
Saskatoon, Saskatchewan, Canada

Campbell, Todd & Jennifer Chenoweth: fisterra studio
Austin, Texas

Canaday, Matt: Canaday Designs
Paso Robles, California

Cooper, James D.W.
Fredericksburg, Virginia

Cristalli, Maria: Cristalli Brown, Inc.
Seattle, Washington

DeMartis, James: James DeMartis Custom Metal Studio
East Hampton, New York

Dillon, Michael: Dillon Forge
Roswell, Georgia

Dunmire, James C.: Waters Edge Forge
Chuluota, Florida

Edelman, Mike
Frostburg, Maryland

Elias, Lisa: Elias Metal Studio
Minneapolis, Minnesota

Elliott, Roberta: The Velvet Hammer, Ltd.
Cobden, Illinois

Eng, Greg
Vista, California

Frank, Rebekah: Texas State University

Gallucci, Jim: Jim Gallucci Sculptor Ltd.
Greensboro, North Carolina

Garcia, Robert
Toledo, Ohio

Gardner, Mindy & Mark: Flood Plain Forge
Farmer City, Illinois

Gehl, John W.
West Bend, Wisconsin

Gilbert, Brian: The Hammer's Blow
Chattanooga, Tennessee

Glennon, Mike: Pleasant Lea Forge
Illinois

Hackbarth, Steve: Badger Village Blacksmithing, Inc.
Merrimac, Wisconsin

Harle, Jørgen
Eastsound, Washington

Henderson, Wayne
Chapel Hill, North Carolina

Higdon, Tony & Erika Strecker
Lexington, Kentucky

Hoecht, Dietrich : Big Bang Forge Inc.
Clayton, Georgia

Howard, Bill: Howard Academy for the Metal Arts
Stoughton, Wisconsin

Intracoastal Iron: Richard Coley, Ben Kastner, Jason Cole; photos Eric Hernandez
Wilmington, North Carolina

Jackson, Frank
Clovis, California

Jenkins, Teresa: Happy Trail Productions, Inc.
Toronto, Ontario, Canada

Jensen, John
Pasadena, California

Krieger, Jed: Iron Wing Forge
Kewaskum, Wisconsin

LaBrash, Jason: Grizzly Iron, Inc.
Phoenix, Arizona

Langdon, Larry Lee: Monster Metal LLC
Auburn, Washington

Latané, Tom
Pepin, Wisconsin

Leritz, Andy: DeForm
Portland, Oregon

Little, John
East Dover, Nova Scotia, Canada

Lovell, Shawn: Shawn Lovell Metalworks
Berkeley, California

Mansfield, Neil: Flying Sparks
Ashland, Massachusetts

Manuka Forge, Inc.: John Monteath & Brenda Field
Calgary, Canada

Markewitz, Darrell: The Wareham Forge
Ontario, Canada

Medwedeff, John: Medwedeff Forge & Design
Murphysboro, Illinois

Metcalfe, Lynda & Elmer Roush: Metcalfe Roush Forge & Design
Brasstown, North Carolina

Mettes, Rik and Brenda Bales, Wyoming Metalsmiths
Powell, Wyoming

Miller, Rachel and Timothy: Spirit Ironworks, Inc.
Bayport, NY

Mosher, Jeff
Easton, New York

Mountain Forge
Truckee, California

Nager, W. R.
Lakeland, Florida

Nauman, Dan: Bighorn Forge Ironworks
Kewaskum, Wisconsin

Noble, Zack
Bakersville, North Carolina

Odom, Robert W.
Loomis, California

Osmolski, Lauren
Seattle, Washington

Paley, Albert: Paley Studios Ltd.
Rochester, New York

Parker, George
Helotes, Texas

Peffers, Kevin: Peffers Plane & Anvil, Ltd.
Burlington, Ontario, Canada

Pepperl, Jim: Pepperl Forge
Silver City, New Mexico

Phillips, John: Phillips Metal Works
Montgomery, Alabama

Pickett, Rod: Forging Ahead Inc.
Durango, Colorado

Price, Greg
Warrenton, Virginia

Rais Studios, John
Shelburne, Massachusetts

Robertson, Bill: Applecross Forge
Tallahassee, Florida

Robertson, David G.
Cargill, Ontario, Canada

Rupert, Robert A.
Clinton, Pennsylvania

Satow, Heath
Alhambra, California

Schultz, Susan
Sandusky, Ohio

Sheffield, Graeme: The Ironwood Anvil
Guelph, Ontario, Canada

Smith, John Boyd: John Boyd Smith Metal Studios
Savannah, Georgia

Sohikian, R. Mike
Genoa, Ohio

Starr, David: Chile Forge
Tucson, Arizona

Sweebe, Scott
Flagstaff, Arizona

Terry, Patrick & Patricia
Oregon City, Oregon

Thayer, Douglas: ThayerHouse Forge & Studio
Webberville, Michigan

Thompson, David
Eugene, Oregon

Wallin, Jeffrey L.: National Ornamental Metal Museum Foundation, Inc.
Memphis, Tennessee

Wiesenfeld, Ira R.
Tucson, Arizona

Wittman, Tessa
Penland, North Carolina

Witzke, George: Witzke Iron Works
Buckhorn, New Mexico

Wolfe, Michael D.: Designs in Iron
Ann Arbor, Michigan

Index

Andirons, 17, 188-192
Anvils, 8
Anvil's Ring, The, 3
Artist Blacksmith's Association of North America (ABANA), 3, 6
Anderson, David E., 228
Archaeology sites, 6
Architectural ironwork, 6
Armourer, 6
Ashtrays, 244
Badger, Lee, 250-253
Beck, Nicole, 66-67
Beds, 34, 165-168
Bell strikers, 250
Benson, Jeff, 68, 138-139, 233-234
Billings, Rudy L., 69
Blacksmithing, history, 6
Blacksmith's art, early examples, 6
Blacksmith's shops, 7
Bladesmiths, 6
Blakney, Andy, 40
Blooms, iron, 7
Bowling, Phillip, 185-187
Bowls, 239, 242-243
Boxes, 235-238
Brown, Bill, 70-72
Bujold, Anne, 73
Calipers, 229
Campbell, M. Craig, 42, 74-75, 154-155
Campbell, Todd, 36, 65, 75, 163, 207
Canaday, Matt, 18-19
Canopies, 246
Censer & incense boat, 240-241
Clocks & clock towers, 249, 251-253
Cole, Jason, 76
Coley, Richard, 76
Cooper, James D.W., 77, 150, 161-162
Cristalli, Maria, 33, 48-49, 78, 184, 203, 247
DeMartis, James, 35, 78, 197
Dillon, Michael P., 9, 52, 168
Doors & door hardware, 17, 63-65, 216-220
Drawbridge, 20-23
Dunmire, James C., 60-61, 79
Edelman, Mike, 80, 159-160, 227
Elias, Lisa, 31, 47, 170, 195, 202
Elliott, Roberta, 81, 207
Eng, Greg, 13-15, 41, 183, 216
Entry Doors, 58
Entryways, 16, 45-46, 54
Farriers, 6
Fences, 7, 47
Fireplace screens, 17, 175-187
Fireplace tools, 188, 190, 194-196
Forge table, 7
Forges, 7
Foundaries, 7
Fountains, 24, 25, 128
Frank, Rebekah, 82, 144, 235
Furniture, 133-174
Gallucci, Jim, 83
Garcia, Robert, 84-85
Gardner, Mindy, 86-87, 144-146

Gates, 9, 43, 44, 47-53, 55-62
Gehl, John W., 88-89, 239
Gilbert, Brian, 137-138
Glennon, Michael, 210, 249
Grilles, 7, 31, 41, 42
Gun barrels, 7
Gunsmiths, 6
Hackbarth, Steve, 8, 90-92, 217, 218, 240-241
Hall Tree, 170
Hammer, 8
Hammer, industrial forging, 9
Hardie hole, 8
Harle, Jørgen, 39
Hearth, 7
Henderson, Wayne, 141-143, 242-243
Higdon, Tony, 182, 204, 245
Higdon, Tony & Erika Strecker, 93
Hoecht, Dietrich, 153, 157, 165-166, 206
Hoods, 174
Howard, Bill, 136, 180, 246
Intracoastal Iron, 10-12, 76, 95
Iron alloy, 7
Iron, cast, 7
Iron, low carbon, 7
Iron smelting, experimental, 55
Iron, wrought, definition, 7
Ironwork, decorative, 7
Jackson, Frank, 94, 245
Jenkins, Teresa, 28-29, 62, 248
Jensen, John Lewis, 221-223
Jernberg, John, 7
Jewelry, 227-229
Johnson, Lloyd, 28
Kastner, Benjamin, 95
Knives, 221-224
Krieger, Jed, 96, 211
LaBrash, Rodger & Jason, 63
Laminations, 7
Langdon, Larry Lee, 40
Latané, Tom, 200, 216, 236-238
Leritz, Andrew, 20-25
Lighting, 197-215
Little, John, 97-98, 172-173, 211
Locks, 230-232
Lovell, Shawn, 34, 168, 178
Magazine racks, 25
Mailboxes, 245
Mansfield, Neil, 152, 188, 226
Manuka Forge, 26-27, 98
Markewitz, Darrell, 55-57, 233
Medwedeff, John, 100-101, 202
Meilach, Dona Z., 3, 4
Metcalfe, Lynda & Elmer Roush, 37-38
Mettes, Rik and Brenda Bales, 170
Miller, Rachel and Timothy, 40, 140, 158, 204
Mirrors, 233-234
Mosher, Jeff, 189-190, 246-247
Mountain Forge, 16-17
Music stands, 170-173
Nager, W. R., 58, 99, 165, 174
Nails, 6
National Ornamental Metal Museum, 77

Nauman, Daniel, 51, 205
Noble, Zack, 62, 102
Odom, Robert W., 103-104
Ornamental ironwork, 6
Osmolski, Lauren, 105-107
Paley, Albert, 9, 43-46, 108-109
Parker, George, 52-54, 191, 198-199
Peffers, Kevin, 32
Pepperl, Jim, 184, 196, 219-220, 244
Phillips, John, 192-194, 214, 218-219, 226
Pickett, Lee, 174
Pickett, Rod, 169, 174
Porch supports, 245
Portals, 43
Price, Greg, 167, 171, 175-177
Pritchell hole, 8
Rais Studios, John, 6, 110, 164, 179, 234
Railings, 10-15, 18-19, 21-22, 26-40
Reception desk, 25
Rejería, 26
Renaissance period, 26
Robertson, Bill, 201, 212, 231-232
Robertson, David G., 64-65, 110-111
Romanesque period, 26
Roush, Elmer, 230
Rupert, Robert A., 112, 224-225
Satow, Heath, 113-116
Schultz, Susan, 117-119
Sculptures, 24, 66-132
Seating, 156-164
Sheffield, Graeme, 120-121
Signs, 24, 225-226
Sledges, 8
Smith, John Boyd, 30, 50, 121, 150, 215
Soft-cast steel, 7
Sohikian, Mike, 122-123, 248
Starr, David, 59
Steel, mild, 7
Strecker, Erika, 124-124, 164, 208-209
Sweebe, Scott, 126, 244
Tables, 133-155
Terry, Patrick & Patricia, 127
Thayer, Douglas, 148-149
Thompson, David, 128-130, 136, 213
Tijou, Jean, 6
Tongs, 7, 9
Towel bars, 125
Tuyere
Vanity, 169
Vices, 9
Wallin, Jeffrey L., 133-135, 206
Weathervanes - windvanes, 248
Well covers, 247
Westminster Abbey, 26
Wiesenfeld, Ira R., 131, 147, 156-157
Wittman, Tessa, 151, 191, 229
Witzke, George, 8, 178
Wolfe, Michael, 64, 132, 181, 195-196, 217
Wood elevators, 246-247
Wrought iron, definition, 7
Yard bells, 244